Trouble in — LAFAYETTE SQUARE

Beth

Happy reading!

Trouble in
LAFAYETTE
SQUARE

*Assassination, Protest & Murder
at the White House*

GIL KLEIN

Foreword by John Kelly,
Washington Post Metro Columnist

THE
History
PRESS

Published by The History Press
Charleston, SC
www.historypress.com

Front cover: Depiction of 1902 Lafayette Square and White House. This painting of the White House and Lafayette Square was completed in 2010 by artist Peter Waddell. It depicts the area as it would have appeared in 1902 during President Theodore Roosevelt's administration. *Peter Waddell for the White House Historical Association.*

First published 2018

Manufactured in the United States

ISBN 9781625858887

Library of Congress Control Number: 2017963924

Notice: The information in this book is true and complete to the best of our knowledge. It is offered without guarantee on the part of the author or The History Press. The author and The History Press disclaim all liability in connection with the use of this book.

To Gail, my partner in history

Contents

FOREWORD

Washington, D.C., is full of metaphors of hearth and home. The Smithsonian Institution is the Nation's Attic. The Mall is America's Front Yard. Pennsylvania Avenue is America's Main Street. And Lafayette Park is…what exactly?

Let's start with where exactly. It's the statue-studded, squirrel-filled patch of green just north of 1600 Pennsylvania Avenue NW. That, of course, is the address of the White House. You might hear it called the People's House, but that nickname is just as likely to refer to the U.S. Capitol or to Congress or to just the House of Representatives. Even though it is literally a house, the White House resists easy domestication—or compartmentalization.

And so, too, does Lafayette Park, aka Lafayette Square. In times of national crisis, national anger or national exultation, crowds will gather there, in front of the White House—protesters can be sure that the president will hear them, if not necessarily listen to them—but in recent years, history has typically been made a few blocks away, in front of the Lincoln Memorial. Those are the photographs you're likely to remember.

And yet there are few images that more immediately communicate a setting and set up a story than the White House. Stick a picture of the White House behind an anchorman or stick a TV reporter in front of the White House, and the audience knows exactly what's up: something is happening in the capital of the United States.

A lot has happened in Washington. A lot has happened in the White House. A lot has happened in Lafayette Park. A lot *keeps* happening. Just pick up a newspaper. (Please.)

Most of that stuff is not the subject of this book.

Rather, Gil Klein strolls around Lafayette Park like a neighborhood busybody looking for gossip. "Neighborhood" might not be a word you typically associate with the Executive Mansion and its environs, but don't forget: the White House is a home. And every home has neighbors. Some are sober and quiet, the kind you can borrow a cup of sugar from. Others throw drunken parties, sleep with married women and challenge people to duels. I know whom I would rather read about.

So, Lafayette Park: not America's Front Yard (that's already taken; see above) but maybe America's Back Yard? A backyard like in one of those suburban subdivisions where the yards aren't fenced and there seem to be no borders and gangs of kids roam from house to house in epic games of tag?

What I mean is, Lafayette Park willingly serves a lot of audiences. Even today, in our post-9/11 world, when bollards are everywhere, it's an inviting place. Office workers flee their cubicles to sit on its benches at lunch. Politicians and lobbyists cross it on their way to visit the president. Tourists angle for photographs. In the spring, it has some of the nicest tulips in the city. In the fall, it has some of the most manic squirrels in town.

In fact, there once were so many squirrels in Lafayette Park—the highest density researchers had ever measured—that the National Park Service was moved to act. The squirrels were stripping the bark and eating the buds from the park's trees, endangering the shady setting. In the dead of night, dozens of squirrels were trapped, loaded into a van and driven to a park on the other side of town to be released.

Did these bushy-tailed transplants miss Lafayette Park? Who can say? I imagine they did, for what can compare to having a front-row seat to history? But not everyone is lucky enough to live or work near Lafayette Park. For us, there is this book.

John Kelly
Washington Post Metro columnist

ACKNOWLEDGEMENTS

I have been gathering information and thinking about this book for many years. Along the way, people have been helpful and encouraging to me in many different ways. Journalism has been my vocation, but from elementary school, American history has been my true interest. I have often said that journalism, especially in Washington, is just studying history as it happens—and you don't have to go the library.

First, I would like to acknowledge Gene Marlowe, who was the bureau chief at the Media General News Service before his untimely death. Just before Washington and the world turned upside down after the 9/11 terrorist attacks, with national news kind of slow, he came up with the idea of having each of us reporters pick a spot in Washington that we found personally special and to write about why. As someone who had soaked in D.C. history since arriving in 1985, and who had covered the White House during the George H.W. Bush presidency, I chose Lafayette Park and put together a story that had many of the elements of this book. Ever since then, I thought it would make a good book. It just took fifteen years to pursue it seriously.

The Decatur House has been instrumental in my work. Every time I toured it, I came back with a new idea. I particularly want to thank three members of the history staff, Edward Lingual, Matt Costello and Evan Phifer, who took the time to talk to me and to open its archives and library. Included in Decatur House lore is the work of Liz Williams, the director of the Gadsby Tavern in Alexandria, Virginia, who told me about the slaves hotel entrepreneur John Gadsby owned when he lived in the house.

Jennifer Krafchik, the deputy director and director of strategic initiatives at the National Woman's Party in the Belmont-Sewell House on Capitol Hill, was generous with her time in explaining Alice Paul, Alva Belmont and the inside workings of the Woman's Party during the suffrage movement. The White House Historical Association had a wealth of information, and Alexandra Lane was most helpful in providing photographs of the White House reconstruction project in 1950. That image of a bulldozer working inside the White House stuck with me since I first saw it in William Seale's 1986 book, *The President's House*.

I would like to thank the Wyoming State Archives for the photos of Senator Lester Hunt, especially Suzi Taylor, the reference archivist.

During a trip south, I was helped by the Woodrow Wilson Museum and Library at Staunton, Virginia, and especially historian Mark Peterson. In Wytheville, Virginia, Farron Smith at the Edith Bolling Wilson Birthplace Foundation and Museum was helpful in filling in the second Mrs. Wilson's views on women's suffrage. In Newport, Rhode Island, I was surprised to learn at Marble House, one of the great Newport Gilded Age "cottages," of the transformation of Alva Vanderbilt from a mansion-building socialite into Alva Belmont, a dedicated women's suffragist.

I want to thank National Press Club member Tom Risen, who alerted me to the story of Senator Lester Hunt, my colleague at American University's Washington Semester Program, Heather Heckel, for insisting that I include a chapter on slavery on Lafayette Square, and Richard Lee for his wise counsel on additions to the book.

As someone who has been interested in the Spanish-American War since high school, I was pleased when my parents moved to Puerto Rico for a short time. During my visits there, I soaked up its history, culture, politics and the complicated relationship it has had with the United States since 1898. I learned much more when I returned there in 1998 for the centennial to write about it for Media General. From the governor's office to the Independence party, doors were opened to me. I have carried that interest into this book.

And finally, my thanks to my buddies at the National Press Club's History and Heritage Committee, who have encouraged me along the way, especially my friend Matt Schudel of the *Washington Post*, who introduced me to columnist John Kelly. His foreword to this book is priceless.

Chapter 1

A Day in the Park

I am sitting on a park bench in the middle of Lafayette Park next to an equestrian statue of Andrew Jackson and looking south to the White House. It's a comfortable spring day. This is not just any park bench. Bernard Baruch, a successful Wall Street financier, who advised Presidents Woodrow Wilson, Franklin Roosevelt, Harry Truman and Dwight Eisenhower, made this bench famous by often sitting here, enjoying the weather and counseling government officials, including Cabinet secretaries, who stopped by to sit with him. He called it his "Bench of Inspiration," and he became known as "the park bench statesman." I know because there's a plaque next to the bench telling me so.

Sitting here, one can almost see the American leaders who passed by. George Washington must have stood here as he conferred with Pierre L'Enfant, who was laying out the nation's capital. L'Enfant designated it the "President's Park," and Washington was involved in buying the property and designing the White House. The story goes that much of the property was owned by an irascible Scotsman named David Burnes, who apparently loved an argument and kowtowed to no one. When Washington visited him to discuss the deal, Burnes said to the president of the United States and hero of the Revolution, "I suppose, Mr. Washington, that you assume people here are going to take every grist from you as poor grain. But what would you have been if you had not married the widow Custis?" That reference that Washington was successful only because he had married the rich Martha Custis so infuriated Washington that he stormed out and let the negotiations be carried out by others.[1]

Behind me is St. John's Episcopal Church, built in 1816, where every president since James Madison has worshiped. Madison was even one of the first property owners on Lafayette Square, and his wife, Dolley, a grande dame of Washington society, lived there until her death in 1849. How she treated her slave, Paul Jennings, is one of our tales.

Abraham Lincoln walked through the park repeatedly to visit Secretary of State William Seward, who had rented a mansion along the park's east side. Lincoln and Seward would plot strategy for the Civil War. We will be hearing a lot about Lincoln

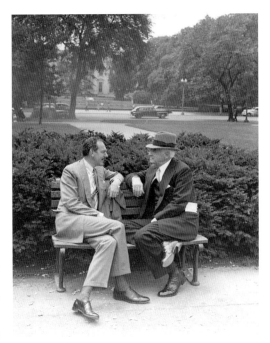

Bernard Baruch (*right*) sitting on his Bench of Inspiration with Secretary of State Dean Acheson. *Kiplinger Library*.

and Seward in this book, but one unusual incident needs to be mentioned here. At the time of the Civil War, a high fence enclosed the park, and it was locked at night. One evening, the British minister and the wife of the Spanish minister found themselves trapped when the gates were locked. Their cries for help were met by a man in a tall hat who happened to be walking by. Lincoln hurried back to the White House and got a ladder and helped the amorous couple climb over the fence to escape.[2]

The seven-acre park in which I sit is officially called Lafayette Park, and it is administered by the National Park Service. But it usually is referred to as Lafayette Square, which includes all the buildings that line Madison Place on the east side, Jackson Place on the west side, H Street NW to the north and Pennsylvania Avenue to the south. At one time, these were the most prestigious residential addresses in the city with Cabinet members, senators, generals, admirals and top presidential advisers residing in the large townhouses.

On my perch on Baruch's bench, I am looking directly into the maw of a cannon, one of four that encircle the statue of Andrew Jackson. These

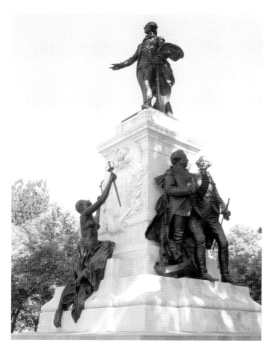

Statue of the Marquis de Lafayette, for whom Lafayette Park was named. It is in the southwest corner of the park and was completed in 1891. *Wikimedia Commons.*

cannons were captured from the British at Jackson's triumph at the Battle of New Orleans that ended the War of 1812. This isn't just any old statue. It was an engineering marvel when it was unveiled in 1853. Designed by sculptor Clark Mills, it depicts General Jackson raising his hat while astride a horse rearing on two legs. Never before—anywhere—had a sculptor managed to have a horse balanced on two legs. The dynamism of the statue lends a vitality to the entire park. Carved into the pedestal are Jackson's words: "The Union: It Must Be Preserved." They will play into a later chapter.

If Andrew Jackson is the central figure in this park, why is it named after Lafayette, whose statue is in the southeast corner and was not constructed until 1891? Lafayette was a mere nineteen years old when, as a French marquis, he came to the fledgling United States during the American Revolution to offer his services to George Washington. Even though Lafayette was so young, Washington made him a general, and he served with distinction throughout the war, ending as a key actor at the Battle of Yorktown, where the French fleet and French troops played a decisive role in the American victory. Forty-three years after Yorktown, Lafayette returned to the United States in 1824 to make a triumphal two-year journey to all twenty-four states then in the Union. At every stop, the old general was greeted by honorary militia guards, feasts, festivals and balls. And everywhere the local citizens named things after him, whether it was Lafayette, Louisiana, or Lafayette, Indiana; Fayetteville, North Carolina; Lafayette County, Florida; Lafayette College in Pennsylvania; even LaGrange, Georgia, named for Lafayette's estate in France. There's a LaGrange in Fayette County, Tennessee. Lafayette visited

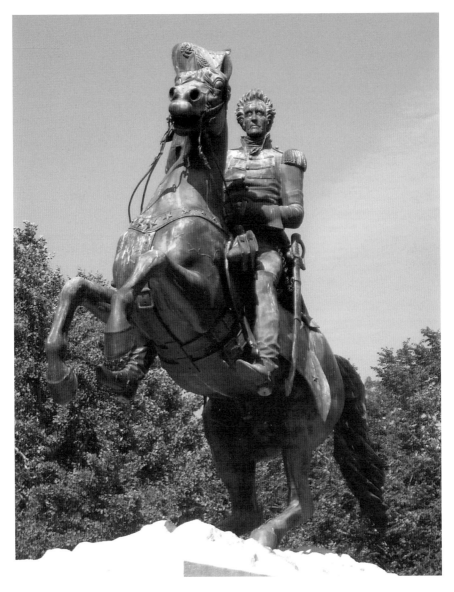

Andrew Jackson statue in the center of Lafayette Park. *Wikimedia Commons.*

Washington twice on his tour—once at the beginning to meet President James Monroe, a fellow Revolutionary officer, and again at the end to meet President John Quincy Adams, son of Revolutionary leader John Adams. It only made sense that something prominent in Washington should be named for him. Hence Lafayette Park and Square became the common names for

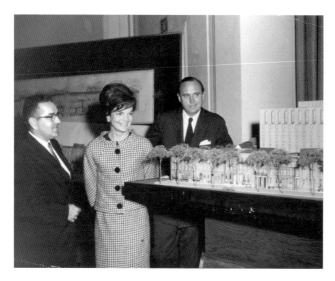

First Lady Jacqueline Kennedy admires a scale model of Lafayette Square's renovation during a press briefing. Joining the first lady are Bernard L. Boltin, administrator of the General Services Administration (*left*), and John Carl Warnecke, the redevelopment's architect. *Courtesy of Abbie Rowe, White House Photographer.*

the area right after the general's visit and officially in 1836, long before the Jackson statue was constructed.

Sitting on Bernard Baruch's bench, I can enjoy the aura of permanence and history created by the buildings along its east and west sides that appear to be mid-nineteenth-century town houses of three and four stories. That's what they were when this was the most fashionable address in the city. However, as both the government and the city grew, pressure built for this to become the center for government offices and courtrooms. Plans called for tearing down most of the nineteenth-century buildings and replacing them with large, modern-style architecture. First Lady Jacqueline Kennedy adamantly opposed the idea. She called the plan for a white modern court building for the east side "hideous" and the plans for replacing the buildings on the west side "the most unsuitable violently modern building." With no one really in charge, she said, "before you know it, everything is ripped down and horrible things put up in their place."[3] In July 1962, contracts for the architects who had planned the buildings that so offended the first lady were terminated, and new architects were brought in who, for the most part, were able to restore the nineteenth-century feel for the square while pushing modern buildings behind their façades and out of sight.

Now on a warm day, if the National Park Service is doing its job to keep the flower beds blooming and the fountains spraying, Lafayette Park is a tranquil place. People can play chess on tables on the west side. Benches are still attractive for reading, chatting and contemplation—or, in this age, talking on cellphones and texting. Pennsylvania Avenue in front of the White

House was closed to traffic after the Oklahoma City bombing in 1995. While that wreaked havoc on the city's traffic flow, it extended the park into the avenue—when the Secret Service isn't pushing people back to the sidewalk for security measures. Hundreds of people—from across the United States and around the world—angle for position to take their photos of themselves, their family and friends with the White House in the background. It probably is still the most photogenic building in the United States. Yes, all can be tranquil and serene as ever in Lafayette Park.

When I arrived in Washington in 1985 to become a reporter for the Media General News Service, I brought along my keen interest in American and presidential history. On my way to work, I would often get off the Metro at the Farragut West station so I could walk across the park to get to the National Press Building. From 1989 to 1993, I was the White House correspondent, covering the George H.W. Bush administration. All along, I picked up tidbits about Lafayette Park's history and read accounts included in histories and biographies about strange events that happened here. I have tried to give those authors their due throughout this book. When I was asked in May 2001 to write a story about my favorite place in Washington, I wrote about the park, encompassing many of the stories in this book.

As a White House correspondent, I can recall how the world changed when the steel gate clanked shut behind me. Inside the fence was kind of a fantasyland. Outside the fence, the real world was peering in. It was not until I researched this book that I realized how much of the turmoil of American history was played out on those seven acres and surrounding buildings just outside the fence.

So, as I sit here on Bernard Baruch's bench, I can look to my right and see the Decatur House where, in 1820, American naval hero Commodore Stephen Decatur was rushed back from a duel only to die a few hours later in the parlor. Or I can contemplate how the same house was part of a social scandal at the beginning of the Jackson presidency that nearly did in the president and may have helped bring on the Civil War. Or, if I look closer toward the White House on the southwest side of the park, I can see a determined Puerto Rican nationalist striding toward the Blair House just around the corner to meet his compatriot to launch a gunfight to try to assassinate President Truman, who was staying at the house. I can imagine a time when no buildings surrounded the park except the White House and see an enslaved woman working away in her garden and selling vegetables to buy her freedom. If I look to my left, I can see the trees near Madison Place where a congressman shot and killed the son of Francis Scott Key in a

jealous rage. Just beyond that is where William Seward's mansion stood. On the night Lincoln was shot, a confederate of John Wilkes Booth burst into the house and nearly killed Seward. I can imagine the adjoining mansions on H Street behind me built by great friends John Hay and Henry Adams, who lived with their wives, and think of Clover Adams's suicide that led to the creation of a great piece of art. I can recall the women suffragists who emerged from the headquarters of the National Woman's Party on the square at the beginning of America's entry into World War I to wave banners that compared President Wilson to Kaiser Wilhelm. Oh, the ruckus that started. Following the precedent those suffragists set, people from across the country and around the world now converge on the park to practice their constitutional right to protest the president's policies and their grievances against the American government. And what happened in the park that may have led a senator to commit suicide?

As the bells in St. John's Church chime the hour on a tranquil day, it can be hard to imagine the murder and mayhem that has at times engulfed Lafayette Park. Yet I can recall a significant September morning in 2001 when the sky was cloudless, the air crystal clear and the temperature warm. I had been at a breakfast organized for journalists at the Sheraton Carlton Hotel just up Sixteenth Street from the park. As the breakfast was breaking up, one of the speakers looked at his cellphone and said, "That's odd. An airplane has crashed into the World Trade Center." As I walked with my friend Dick Ryan of the *Detroit News* back to the National Press Building, we pondered the significance of that news as we enjoyed the tranquility of the park. Had we been just a couple of minutes later, we would have been trampled by hundreds of people streaming out of the White House and surrounding office buildings, some of them removing their shoes so they could run faster, because terrorists had hijacked another aircraft and could be heading that way.

Yes, everything is tranquil in Lafayette Park—until it isn't. And that's what this book is about.

Chapter 2

A Hero's Death
in Lafayette Square's
First House

For a young America, eager for heroes and seeking to assert its place among the nations, Stephen Decatur was legendary. Born on January 5, 1779, he grew up in Philadelphia. His father, Stephen Decatur Sr., was a successful naval officer in the Revolution and in the early years of the American republic during a quasi, undeclared war with the French.

During Thomas Jefferson's administration, the United States was at war with the Barbary States in North Africa: Algiers, Tripoli and Tunis. All three attacked American merchant shipping in the Mediterranean Sea, demanding ransom to release crews as well as tribute to allow safe passage. Jefferson, who opposed a large military, reluctantly sent warships to the Mediterranean to protect American shipping. In 1805, one of the premier ships in the American fleet, the USS *Philadelphia*, ran aground off Tripoli and was captured. American naval officers knew that if the *Philadelphia* were repaired and rearmed, it would shift the balance of power in the Mediterranean in favor of the Barbary States.

At the age of twenty-five, after just six years at sea, Decatur volunteered for what seemed like a suicide mission: sneak a small ship into the Tripoli harbor with a crew of seventy-five right under the guns of the city's fort, overwhelm the Tripolitan crew aboard the *Philadelphia* and set it ablaze. Disguising a ketch—a small two-masted ship—as a British merchant ship and hiding most of his crew below deck, Decatur sailed into the harbor as night fell and even convinced the Tripolitan sailors to allow him to tie up his ship against the *Philadelphia*. On his signal, Decatur's crew rushed aboard the

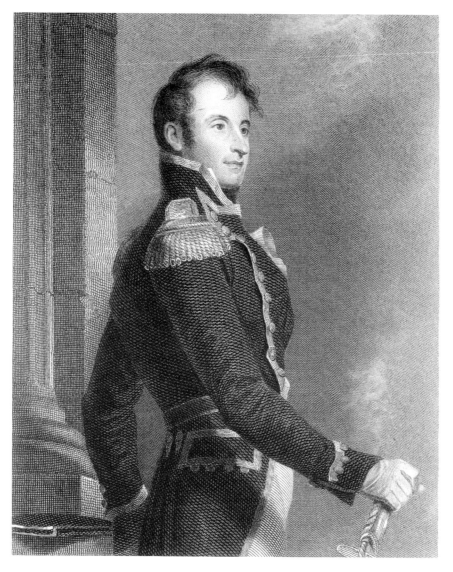

Commodore Stephen Decatur. *Library of Congress.*

Philadelphia, overwhelmed the crew and set the ship ablaze. Decatur was the last man off, jumping back onto the ketch just ahead of the flames. Batteries from the fort began firing at the escaping American ship, but it soon was out of range as the Americans gave three rousing cheers. With just one seaman wounded in the fray and one enemy cannonball piercing a sail, the raid was overwhelmingly successful.

"Decatur's destruction of the *Philadelphia* captured the imagination of the American public and set a standard of audacity and courage for generations of future naval officers," Spencer Tucker writes in his biography of Stephen Decatur. British admiral Horatio Nelson called it "the most bold and daring act of the age." Decatur was promoted to captain, making him the youngest captain in American naval history.[4]

But that was just the beginning of Decatur's illustrious career. During the War of 1812, he was lionized for capturing the British frigate *Macedonia*, outfighting what was considered one of the best frigate captains in the Royal Navy. After the war, he commanded a fleet headed back to the Mediterranean Sea. The dey of Algiers had taken advantage of the American turmoil with Britain to capture American merchant ships with encouragement and supplies from the British. Within two weeks of ratification of the treaty ending the War of 1812, Congress authorized President Madison to take action against Algiers. Decatur led the first American fleet of ten ships, the largest ever to set sail. After Decatur captured two Algerine warships and killed an admiral, the rest of the Algerine navy fled to neutral ports. Decatur sailed his fleet to Algiers and demanded a peace treaty on American terms. When it was signed, Decatur informed the American secretary of the navy, Benjamin Crowninshield, that since the treaty had been negotiated "at the mouth of the cannon,"[5] enforcing it would require an American fleet in the Mediterranean—where it remains to this day.

Just seventy-one days after sailing from New York, Decatur defeated one of the Barbary States and convinced the other two to restore normal relations with the United States. American ships now could trade in the Mediterranean without fear of attack. On his return, he was honored with dinners celebrating his achievement. At one of them, he returned to toasts with one of his own that has gone down in history as legendary: "Our country! In her intercourse with foreign nations, may she always be in the right; but our country right or wrong!"[6]

Decatur's ventures also made him a wealthy man. In those days, governments awarded victorious naval crews prize money for the ships they captured or sank, and the captain got the lion's share. Returning to the United States, Decatur was appointed one of the commissioners to the Navy Board, a group of officers who advised the secretary of the navy, and he decided to settle down in Washington. He wanted to build a house worthy of a man of his stature and wealth, and that brings us to Lafayette Park, which at the time was still called President's Park and had no houses. Not until 1803 had President Jefferson decided that the park should be

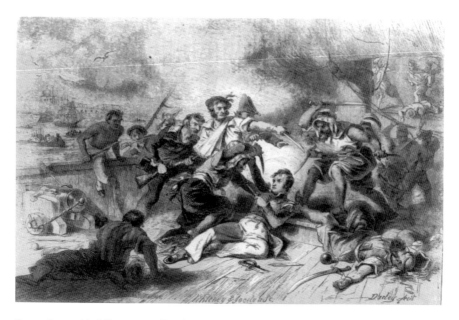

Engraving entitled *Desperate conflict of American Seamen under Decatur on boarding a Tripolitan corsair. Library of Congress.*

public and not part of the White House grounds, and it had been in a deplorable state through the War of 1812, when the White House was burned. With the rebuilding of the White House and construction of St. John's Church on the other side of the park, the square began to become fashionable, and Decatur bought up several lots near it, as well as two on the northwest corner.

The house was designed and built by Benjamin Henry Latrobe, who is known as America's first architect. He had worked on the White House and the Capitol, as well as St. John's Church, before accepting the commission for Decatur's house. It is a basic English design where family living spaces are on the first floor, but guests would be guided out of the vestibule and up the grand staircase for formal entertainment in the ballroom and large dining room. The house is the only one on Lafayette Square still open to the public. It is owned by the National Trust for Historic Preservation and operated by the White House Historical Association. The vestibule just inside the front door is painted just as it was in Decatur's day: light blue walls, chrome yellow baseboards and white doors. If Decatur walked in now, he would recognize it immediately as looking the same as the day he entered with his wife, Susan, to begin a life of parties and power.

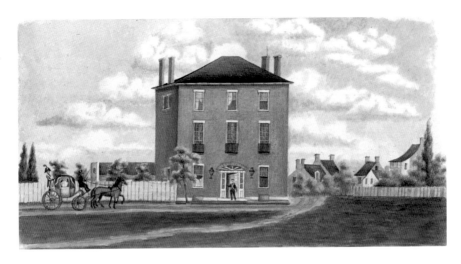

Painting of Decatur House as it appeared in 1822. *White House Historical Society.*

Now the story of the American hero begins to turn dark. Decatur's rapid rise and national fame piqued jealousy among some of the other naval officers who believed their contributions had been overlooked. Among those most angry was Commodore James Barron. At one time, he had been Decatur's superior when, as a new lieutenant, Decatur sailed on his first mission to the Mediterranean on the USS *New York* under Barron's command. Now Barron's career languished, and he blamed Decatur.

In 1807, Barron had commanded the USS *Chesapeake*. At that time, the British were in a desperate war with France under Napoleon. British seamen often deserted to take berths with American naval and merchant vessels, where conditions were much less severe. British warships often stopped American ships to take back seamen they claimed were British subjects. Controversy over these seizures roiled British-American relations and eventually contributed to the War of 1812. But that was still five years off when the *Chesapeake* sailed out of Norfolk bound for the Mediterranean. A larger British ship, the *Leopard*, stopped the *Chesapeake* not far off the American coast. Barron was so certain this was a peaceful encounter that he did not order his ship prepared for action. When the British demanded to be allowed to search the *Chesapeake* for deserters, Barron refused. Only then did he see that the British were not going to act peacefully, but by then, it was too late. The *Leopard* fired three broadsides into the *Chesapeake*, and Barron had no alternative but to surrender. The British took the sailors they wanted and left Barron to sail his badly damaged ship back to Norfolk. Three of his men had

been killed in the action and eighteen injured, one critically. Barron himself had been wounded. In the aftermath, American public opinion demanded war with Britain, but President Jefferson demurred. Barron was relieved of his command. Decatur was promoted to commodore and put in command of the *Chesapeake* and the gunboats in Norfolk Harbor as he rapidly ordered repairs and training of the crew in preparation for war. Decatur served as judge on Barron's court-martial that found Barron guilty of neglecting to clear his ship for action in the face of probable action against the *Leopard*. He was suspended from the navy without pay for five years beginning on February 8, 1808.

That suspension ended during the War of 1812. By that time, Barron was in Sweden and claimed he could not return to the United States when he was called back to service. He said he could not raise the money for passage. The war ended before he returned. But when he did, he asked for a commission in the peacetime navy. Decatur, in his role on the Navy Board, turned him down. With the navy downsizing, why would it give a command to an officer who did not rally to the colors during wartime?

Egged on by fellow officers who may not have had their best interests at heart, Decatur and Barron exchanged a series of heated letters. Decatur told Barron he would not challenge him to a duel and said that if he wanted a fight, Barron would have to make the challenge. On January 16, 1820, he did: "The whole tenor of your conduct to me justifies this course of proceeding on my part."[7] Decatur's response was, in effect: OK, bring it on.

Dueling was still an accepted practice between men in the first half of the nineteenth century, despite efforts of law enforcement and clergy to condemn it. Gentlemen believed they had to uphold their honor at any cost, and any slight would be countered by a challenge. Certainly, if the vice president of the United States, Aaron Burr, could challenge former Treasury Secretary Alexander Hamilton, then dueling was accepted. Andrew Jackson fought duels before he was president, and Secretary of State Henry Clay challenged Representative John Randolph to a duel after the congressman accused him on the House floor of "crucifying the Constitution and cheating at cards." Despite two rounds, neither man was hit.

The navy had the reputation as a hotbed of dueling, although naval historian Christopher McKee insisted it was overstated. Only eighteen naval officers had been killed by dueling before 1815, he said, a mere 1 percent of all the naval officers who left the service before that date. It usually was confined to the younger officers, who were still in their late teens or early twenties. If either the challenger or the one challenged refused to fight, he

would be labeled a coward and suffer stigmatization, if not social ostracism.[8] As a young officer, Decatur had participated in a duel as a second, meaning he was the person who acted for one of the duelers in arranging the fight. While dueling was condemned in the navy, it did not stop because it was not explicitly forbidden by the navy's basic disciplinary code.

That brings us to the morning of March 22, 1820. Decatur biographer Spencer Tucker tells the story this way:[9] Decatur and his second, Captain William Bainbridge, as well as a friend, Samuel Hambleton, headed out in a carriage toward the Maryland border. Since dueling was illegal in the District of Columbia, an area near Bladensburg just over the border had become a favorite dueling ground. Decatur had told his wife nothing of the impending duel but had quietly arranged for some of her relatives and friends to be visiting her in case moral support was needed.

The duel was set for 9:00 a.m. Barron met Decatur at the dueling ground with his second, Captain Jesse Elliott. The two seconds had met days earlier and agreed to the ground rules: pistols at eight paces, a close and deadly distance for dueling. Some historians say there is evidence that even though Decatur had chosen him as his second, Bainbridge was secretly fomenting the dispute because he was jealous of Decatur. With pistols loaded, Bainbridge measured out the eight paces. As the two duelers faced each other, Barron told Decatur that if they met in the next world, he hoped they would be better friends. Decatur replied, "I have never been your enemy, Sir."

The two duelers fired simultaneously, both aiming at the other's hip to disable but not kill. Both shots hit home, but the one striking Decatur did far more damage than the one striking Barron. Everyone there knew it was fatal. "I am mortally wounded, at least I believe so, and I wish I had fallen in defense of my country," Decatur said. Lying next to Barron for a while before he was lifted into his carriage, Barron, believing he, too, would die, said the duel had been conducted honorably, and he forgave Decatur from the bottom of his heart. Decatur said he had opposed Barron's reinstatement because he had not returned during the war. He asked him why. "Because I had not the means." Bainbridge told the story differently. He said Barron replied, "I will tell you what I had not expected to tell a living soul. I was in an English prison for debt."

Rushed back to the house in Washington, Decatur insisted that his wife and two nieces go upstairs before he was brought in. He was carried through the front door, past the still nearly new light blue walls with the chrome yellow baseboards and through a door to the left into the parlor. He finally relented and allowed Susan to come see him. No furniture is in the room

now, but one can imagine, while standing there, the death scene that lasted until ten o'clock that night.

Decatur was universally admired at the time of his death. How popular? Decatur biographer Robert Allison's description of the naval hero's funeral gives a good account of what happened from the time word of the duel circulated in Washington until his funeral.[10]

Business in Washington ceased. In the House of Representatives, the Speaker could hardly keep the members in order, "so anxious do they seem to ascertain the particulars and so generally was Commodore Decatur beloved by the members." President Monroe cancelled his afternoon receptions. From the moment Decatur fell, nothing else was thought of.

On the day of the funeral, thousands of mourners—most of the population of Washington, Georgetown and Alexandria—thronged to the Decatur House. When it was time to start the procession, the house was so packed that movement was impossible. The funeral director came to the door, telling all who were not either members of Congress or officers in the military to back away. A sailor told him, "I tell you what, mister. There's other people besides officers and members of Congress that respect Commodore Decatur, and I say by G--, they shall go in."

The director gave up his order of march and reversed it: the citizens would lead and the dignitaries would follow. All of official Washington was there, including President Monroe, Chief Justice John Marshall and most of the House and Senate, since both chambers had adjourned for the day in Decatur's honor. "Since the foundations of this city were laid, no such assemblage of citizens and strangers, on such an occasion has been seen," one newspaper account said.

The procession's pace was set by a dirge from the Marine Band, and the guns fired at intervals of one minute at the navy yard, their sound growing more distant as the thousands of citizens walked from President's Square to the Joel Barlow estate, Kalorama, on Rock Creek, where Decatur's body was laid to rest.

As an odd footnote to the account, Matthew Costello, a history researcher at the Decatur House, came across an article that appeared in the December 23, 1883 *Chicago Tribune*. It is the story told by a woman who, as a young girl, often visited the house after the commodore's death. She said Susan had put Decatur's bloodstained clothes into a glass globe about two feet in diameter, where they could be seen but never touched. "They were the clothes worn by Decatur when they brought him home done to death by the red-handed Barron, and they were drenched in places with his blood. Mrs.

Decatur had put them in the globe, and never allowed them to be touched. She gave up that society in which she had been a queen, and became dévoté; and many an hour she spent on her knees before this globe praying for the soul untimely sped and (sublime effort of religion!) for him whose hand had driven it forth into eternity."[11]

Could that be true? No such globe has been found, and the belongings of the Decatur family were dispersed long ago when Susan had to leave the house. To try to make ends meet, she rented it to high-ranking government officials, including three successive secretaries of state: Henry Clay, Martin Van Buren and Edward Livingston. And therein starts the tale of our next mayhem on Lafayette Square.

A Social Fracas Nearly Destroys a Presidency

ndrew Jackson is a larger-than-life figure in American history. He was the hero of the Battle of New Orleans who boosted American pride at the end of what had been a stalemated War of 1812. Known for his tall, gaunt figure, his white mane, his overbearing personality and the bullet lodged near his heart during a duel—which he won—Jackson was a formidable figure in American politics. Born in North Carolina, he made his legal career in Tennessee and was elected to one term in the House of Representatives and served less than three years in the U.S. Senate. But his real claim to fame was as an officer in the Tennessee militia. He was the first president who was not an easterner and who was not directly tied to the founding fathers of the American Revolution. Yet he still bore a scar on his head from a saber blow inflicted during the Revolution by a British officer when the fourteen-year-old Jackson refused to clean his boots.

Jackson's administration is known for democratizing American politics, giving more common people—as long as they were white men—a say and a vote. Jackson destroyed the Bank of the United States in the name of dispersing American economic power. He forced most of the American Indians in the South to move west of the Mississippi River in the infamous Trail of Tears. And he stared down a secessionist movement in South Carolina by saying he would send federal troops to put it down.

Martin Van Buren is a smaller-than-life figure in American history. Succeeding Jackson in the presidency, he presided over the worst economic depression in the country's young history, caused in no small part by

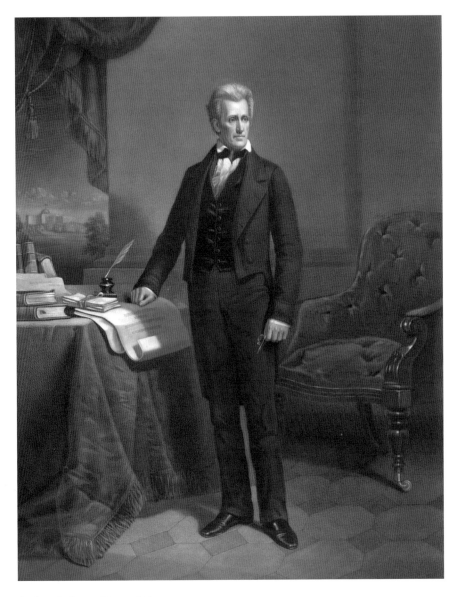

Andrew Jackson. *Library of Congress.*

Jackson breaking up the Bank of the United States. If Van Buren is known for anything, it is his nickname, the "Little Magician." The Democratic Party reluctantly nominated him to run for reelection but didn't allow him to pick his own vice president. He was overwhelmingly defeated by William Henry Harrison, the candidate of the newly formed Whig Party,

who ran on the image—not necessarily true—of living in a log cabin and drinking hard cider.

Yet Jackson's administration nearly was destroyed in its first year in a dispute that roiled the city's social elite over the honor and reputation of the wife of the secretary of war. Into this fracas that lasted nearly a year stepped Secretary of State Van Buren, who figured out how to defuse it while at the same time using it to endear himself to Jackson and become his heir apparent. And the Decatur House, which Van Buren rented from Susan Decatur, was a backdrop of the dispute that some historians have said helped bring on the Civil War.

Rolled up in this story are the political system and turmoil of the time, the social mores that dictated proper etiquette and the unyielding personalities not only of President Jackson but also his vice president, John C. Calhoun of South Carolina, his wife and the wives of the other Cabinet secretaries.

The story goes back to October 1788, when a twenty-one-year-old Jackson arrived in Nashville to make his career as a lawyer. He was smitten by Rachel Donelson Robards, a young woman not only known for her beauty but also described by a contemporary as "gay and lively…the best story teller, the best dancer, the sprightliest companion, the most dashing horsewoman in the western country."[12] The only problem was that she was tied into an unhappy marriage with Lewis Robards, who was jealous of Jackson's attentions to his wife. To make a long story short, Robards left Nashville for Kentucky alone. When Jackson heard in late 1790 that Robards had gotten a divorce, he quickly married Rachel, only to learn that Robards had only filed for divorce. It was not granted until 1793. That meant Jackson had been married to another man's wife, which was not necessarily a bad thing in the western frontier of the time. But it was not okay when Jackson was running for president.

The administration of James Monroe (1817–25) had been known as the "Era of Good Feelings." Monroe had been elected twice nearly unanimously in the Electoral College. All national politicians claimed to be part of the Democratic-Republican Party. With his hero status from the War of 1812, Jackson developed a large political following. In his first bid for the presidency in 1824, he received the most electoral votes and the most popular votes. But he was in a four-way race with Secretary of State John Quincy Adams, House Speaker Henry Clay and Secretary of the Treasury William Crawford. Since no candidate received a majority of the electoral vote, the election was decided in the House of Representatives. Adams and Clay combined forces to reach a majority, thus electing Adams president.

Adams named Clay secretary of state. Jackson's supporters denounced this as a "corrupt bargain," and with a majority in Congress allied to Jackson, the Adams administration was unproductive. In a rematch between Adams and Jackson four years later, Jackson trounced Adams.

But during the 1828 election, Adams's supporters attacked Rachel Jackson, dredging up the fact that she had married Jackson before her divorce and calling her a bigamist and a "profligate woman" unfit to be the wife of the president of the United States. "The enemies of the General have dipped their arrows in wormwood and gall and sped them at me," she lamented.[13] Shortly after the election, Rachel died, and Jackson was convinced that his sainted wife's health had been destroyed by these attacks. He arrived in Washington in a grim mood.

All of this sets the scene of what is to come.

John C. Calhoun was the only vice president to serve under two presidents: John Quincy Adams and Andrew Jackson. The fiery South Carolinian had been involved in national politics since 1811, when he was first elected to the House. He already had served as secretary of war in the Monroe administration. He came into American politics as an ardent nationalist. That he had ambitions to be president was no secret, and he planned to succeed Jackson.

Equally ambitious to move to the top spot was Martin Van Buren. Involved in politics his whole life, he had served in the New York legislature,

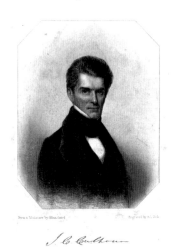

Vice President John Calhoun of South Carolina. *Library of Congress.*

as attorney general of New York and as a U.S. senator from 1821 to 1828 before being elected governor. After only two months as governor, he was only too happy to accept Jackson's offer to be secretary of state to return to national governance. Van Buren marks a great divide in American politics. Born in 1781, he was the first president who was born as an American citizen. He grew up in Kinderhook, New York, a town about twenty miles south of Albany and perhaps the inspiration for Washington Irving's "The Legend of Sleepy Hollow." Even though they had been in Kinderhook for more than a century and a half, the Van Burens and their neighbors still spoke Dutch, making him the first president who was not a native English

Martin Van Buren. *Library of Congress.*

speaker. He was raised in a tavern, which also served as a polling place and was a political center for the area. He was the first president who had neither a college education nor military service. He was not of the plantation South or the Harvard elite who had been president so far. Unlike past presidents, he was an ardent politician from his earliest days, and he has been credited with helping to define the Democratic Party. His biographer, Ted Widmer, said Van Buren understood the pressure points of politics instinctively. "His mastery of these invisible skills may explain why so much power seemed to flow to him, without apparent exertion." That—along with his five-foot-six-inch height—is how he got his nickname: the "Little Magician."

While he was active in the age of giants—such as Jackson, Calhoun, Daniel Webster, Henry Clay and Thomas Hart Benton—Van Buren "more than any other American" had the vision for empowering the common person and built the political mechanisms that created the "party caucus, the nominating convention, the patronage system, the publicity network, and the Democratic Party itself….He spoke a new dialect for the new men of the 19th century, a dialect that had not yet been spoken in America, but which has been spoken at a loud volume ever since."[14]

Van Buren's style was the opposite of Jackson, who was direct, short-tempered and blustery. Widmer said Jackson often did not foresee the long-term consequences of his tantrums. That's why Jackson and Van Buren complemented each other and worked well together. Calhoun, on the other hand, was much like Jackson; they even looked a lot alike. For that reason, Jackson and Calhoun had a hard time tolerating each other. Jackson came to the presidency in poor health, leading political operatives of the time to wonder if he would run for a second term—or survive his first. That made the fight to be heir apparent brutal.

Into this already combustible mix comes Peggy Eaton, the new wife of Secretary of War John Henry Eaton. Secretary Eaton was not just any Cabinet pick. Like Jackson, he had been born in North Carolina and migrated to Nashville to be an attorney. They were close friends, and

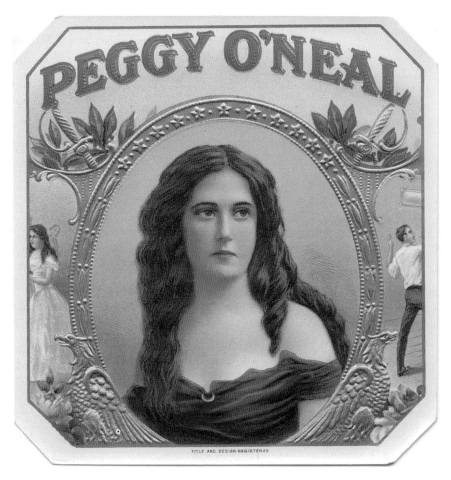

Peggy O'Neale Eaton as depicted on a cigar box label (with incorrect spelling), indicating that this fracas had entered the popular culture. *Wikimedia Commons.*

Eaton served as the U.S. senator from Tennessee for eight years before his appointment to Jackson's Cabinet.

Margaret "Peggy" O'Neale was the daughter of William O'Neale, who ran a popular boardinghouse in Washington called the Franklin House. In those days, legislators often stayed at such boardinghouses while Congress was in session, and both Eaton and Jackson had stayed at the Franklin House when they were senators. Jackson biographer John Meacham describes Peggy this way: "Beautiful and brash, aggressive and ambitious, Margaret Eaton seems to have had few impulses on which she did not act, few opinions that she did not offer, few women whom she

did not offend—and few men, it appears, whom she could not charm if she had the chance to work on them away from their wives."[15] She was, by all accounts, beautiful—and tactless at a time when decorum ruled society. She had been married to a navy purser, John Timberlake, who spent a lot of time at sea, leaving his wife at home in the tavern. He died in 1828; some said he committed suicide when he learned of his wife's unfaithfulness. Margaret herself was coy about how much of these rumors were true: "While I do not pretend to be a saint, and do not think I ever was very much stocked with common sense, and lay no claim to be a model woman in any way, I put it to the candor of the world whether the slanders that have been uttered against me are to be believed."[16] When Eaton approached Jackson about marrying Margaret shortly after Timberlake's death, he said that rumors were circulating that he and Margaret had cuckolded Timberlake. Jackson apparently dismissed it, saying, "Your marrying her will disprove those charges." He enthusiastically endorsed the marriage.

But the ladies of the Cabinet thought otherwise. Led by the indomitable Floride Calhoun, a grande dame of South Carolina plantation society, they refused to have anything to do with Margaret Eaton and snubbed her at every opportunity. As Van Buren biographer Widmer notes, since the end of the War of 1812, "a formidable force had been gathering strength in the capital—the influence of political wives. Nearly as soon as the British retreated, they advanced, and in the 1820s, as Washington became less an architectural sketch and more of a genuine community, it was inevitable that these powerful spouses would feel their growing power over the destinies of the young republic. And they would advance their power through the weapons of mass destruction at the time: gossip, innuendo and outright slander."[17] The issue even divided Jackson's own household. The wife of his adopted son, Emily Donelson, had come from Tennessee to serve as official White House hostess. "The ladies here in one voice have determined not to visit her," she wrote home.[18]

Jackson was furious. He drew parallels between the slanderous remarks against Peggy Eaton and the attacks questioning his beloved wife's virtue during the campaign that he believed helped bring on her death. He commented, "I would rather have live vermin on my back than the tongue of one of these Washington women on my reputation." He closed ranks with Secretary Eaton, demanding that the wives of his Cabinet accept Margaret. He soon began to see the fracas as part of a political conspiracy to undermine his authority and his popularity with the public.

That's when Martin Van Buren went to work. Renting the Decatur House, he was within sight and a short walk from the White House. And as a widower, he had no wife to have an opinion or make a stand. In fact, he may have liked Peggy Eaton. Both had been raised in taverns and were not born into the social elite. One of the first things he did when he arrived in Washington was to call on the Eatons, and he was always happy to attend social events that included them. At the same time, Van Buren would often walk over to the White House to talk with the president and go for walks and horseback rides with him. He soon became the rock of Jackson's administration. That just infuriated Calhoun all the more as he sensed that Van Buren was ingratiating himself with the president at Calhoun's expense. The presidency was slipping from his hands.

The Eaton affair was not a momentary problem. It consumed much of the first half of Jackson's first term. Every social event became a battleground. Van Buren tried to use the Decatur House and its grand ballroom to host parties that would attract Washington society to make peace with the Eatons. Near the end of 1829, he hosted a dinner, but not one Cabinet wife appeared, including Peggy Eaton. Shortly thereafter, he planned an even more elaborate affair—this time well attended. Even Calhoun attended; his wife was back in South Carolina. The evening was going well, and to get a little relief from the crowd, Van Buren slipped downstairs to the parlor—the same place Decatur had died—to sit on the sofa. Within minutes, he was interrupted. Apparently, Margaret had bumped into the wife of Alexander Macomb, the commanding general of the U.S. Army. They began to quarrel, and Van Buren was forced to "prevent a fight."[19]

A year later, the issue still had not been resolved. Jackson had been hamstrung from getting much accomplished in his administration since the infighting was so intense. Van Buren could see that all of this might not be advancing his political ambitions. He devised a plan that could help him and free Jackson of the political intrigue at the same time: he would resign as secretary of state. Jackson was appalled, but over the course of two long horseback rides, Van Buren laid out the plan, and Jackson came to see the benefits. The next day, after meeting with Jackson, Van Buren and Eaton walked to the Decatur House for supper. As soon as they got into the house, Eaton said, "Why should you resign? I am the man about whom all of the trouble has been made and therefore the one who should resign." Those were the words that Van Buren was looking for. He told Eaton to ask his wife what she thought of his resignation. He came back the next day and said she favored it. They went to Jackson, who quickly agreed and decided to fire

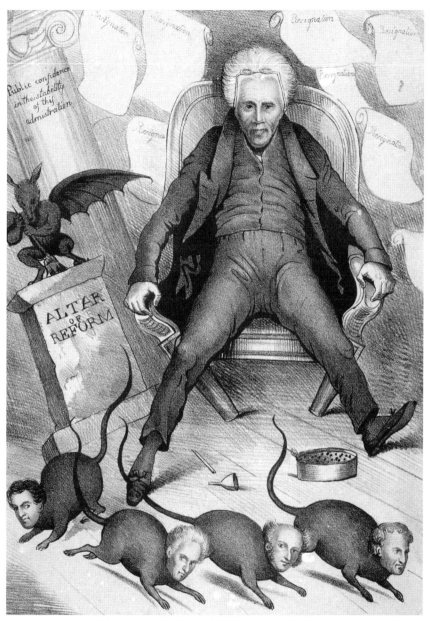

A contemporary political cartoon by Edward W. Clay shows President Jackson seated in a collapsing chair, with the "Altar of Reform" toppling next to him and rats scurrying at his feet. The rats are (*left to right*): Secretary of War John H. Eaton, Secretary of the Navy John Branch, Secretary of State Martin Van Buren and Secretary of the Treasury Samuel D. Ingham. Jackson's spectacles are pushed up over his forehead, and his foot is planted firmly on the tail of the Van Buren rat. "Resignations" fill the air behind him, and a pillar marked "Public confidence in the stability of this admistration [*sic*]" falls to the left. *Library of Congress*.

two other Cabinet members to make a clean sweep, holding over only the postmaster general.[20]

The *New York Courier* commented, "Well indeed may Mr. Van Buren be called 'The Great Magician' for he raises his wand and the whole Cabinet disappears."[21]

Jackson had been able to get rid of what had become known as the "Petticoat Affair" and jump-started his administration with a new Cabinet free of high society intrigue. Eaton was appointed governor of the Florida territory. Van Buren was appointed minister to the Court of St. James in Great Britain. And indeed, when Jackson ran for a second term, Calhoun was out and Van Buren became vice president on his way to the presidency. But the nation suffered consequences for the chicanery. As he saw his quest for the presidency slipping away, Calhoun's political philosophy shifted from ardent nationalism to champion of states' rights. Maintenance of the Union was not his first priority; defending the rights of states against the federal government was. Or "plotting his revenge," as Widmer wrote.[22]

It wasn't long before Calhoun was leading the movement to allow states to reject federal laws they found offensive. The federal government was a voluntary union of the states, and therefore states had the right to nullify federal laws. As early as 1830, at a dinner in Washington planned by Calhoun to promote states' rights, Jackson rose to give a toast. Staring directly at Calhoun, he said, "Our Union: It must be preserved." Calhoun, visibly shaken at this challenge, replied with his own toast, and everyone there could read the code words: "The Union—Next to our liberty most dear." Into that tension, Van Buren rose next with a conciliatory toast: "Mutual forbearance and reciprocal concessions: through their agency, the Union was established—the patriotic spirit from which they emanated will forever sustain it."

That's what a year of the Peggy Eaton affair had led to.

Noting Van Buren's first visit to the Eaton household when he arrived in Washington, Jackson biographer James Parton wrote in 1860 on the eve of the Civil War, "the political history of the United States, for the last 30 years, dates from the moment when the soft hand of Mr. Martin Van Buren touched Mrs. Eaton's knocker."

Widmer said there's a lot to that. "We can laugh at the melodramatic writing, but something rings true about that grandiose claim. Jackson never forgave Calhoun for his role in the Eaton affair and never forgot his gratitude to Van Buren. One could even argue that the Civil War sprang from Peggy Eaton's peccadilloes—for Calhoun's rage at Van Buren was

just the beginning of a lifelong mania against northern political power. In a sense, it is all one story, and secession arguably resulted from succession—or specifically Calhoun's failure to succeed Jackson."[23]

Frustrated by the vice presidency, Calhoun resigned in December 1832 to take a U.S. Senate seat. While he served as secretary of state in John Tyler's administration, he returned to the Senate to champion the South. Close to death as the Senate debated the Compromise of 1850, he railed against the North as the stronger portion of the country. If the North was not willing to protect southern rights, the two sections should "agree to separate and part in peace. If you are unwilling we should part in peace, tell us so; we shall know what to do when you reduce the question to submission and resistance."[24]

And his long-sought Van Buren presidency? A disaster. Within months of his taking office, the Panic of 1837 gripped the economy, sending it into a nosedive. Van Buren did not know how to deal with it. He soon became a laughingstock of the nation, mocked for living like royalty as the common man suffered. He spent much of the rest of his life trying to regain national prominence, first trying unsuccessfully to win the Democratic nomination in 1844, then in 1848 as the nominee of the antislavery Free Soil Party, which went on to be the basis of the Republican Party. But Van Buren returned to the Democratic fold to support Stephen Douglas in the 1860 election and to work in the futile effort to unite northern and southern Democrats. Supporting Lincoln's efforts to save the Union when war broke out, he died in February 1862.

But all that was still ahead as Van Buren departed for Great Britain. He left the Decatur House, which was rented to his successor as secretary of state, Edward Livingston. When, a few feet away in the center of the park, Jackson's statue was erected in 1854, his toast was etched in stone and inspired Lincoln.

While the hubbub and gnashing of teeth at the highest levels of government and society were racking the young republic, the work to support those people in their high style was going on behind the scenes, largely unnoticed. That leads us to the next chapter, where at least a few of the slaves working in and around Lafayette Square had their own stories to tell.

THE PLIGHT OF SLAVES ON
LAFAYETTE SQUARE

S lavery was legal in Washington, D.C., until the middle of the Civil War. That's one reason why the nation's capital was carved out of two slave states—Maryland and Virginia—over the objections of antislavery politicians. Southerners feared that if the capital were in New York or Philadelphia, they would have trouble taking their enslaved servants with them to attend to government business. Indeed, at the time the capital was in Philadelphia, Pennsylvania law stated that any slave who remained in the state for six months would be free.[25] President George Washington made sure that the nine slaves he had brought to Philadelphia were moved out of the state every six months, if only for a few hours, to avoid conflict with the law. Yet one of First Lady Martha Washington's favorite slaves—Oney Judge—ran away with the help of the city's free African Americans when she heard she was going to be given to Martha's granddaughter as a wedding present. She lived the rest of her life as a fugitive in New Hampshire.[26]

But slavery was always a bit tenuous in the District of Columbia. Pressure to abolish the slave trade in the capital, if not slavery itself, grew. Some District residents objected to seeing slaves chained together on the streets of the city. That was one reason why the part of the District that had been carved out of Virginia, including the city of Alexandria, successfully petitioned to be given back to its original state in 1846. Alexandria had a thriving slave market, and

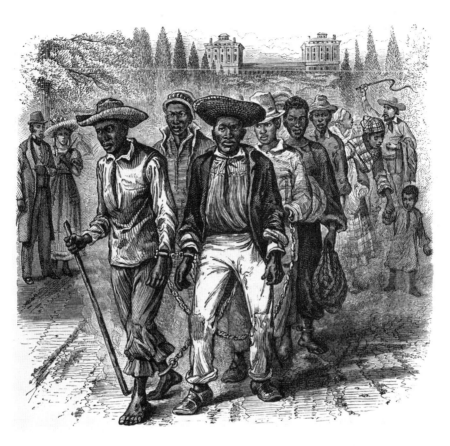

Slaves chained together moving down Pennsylvania Avenue with the Capitol (still under construction) in the background. *Library of Congress.*

it returned to Virginia just four years before the Compromise of 1850 ended the slave trade in the District.

In such a confined neighborhood as Lafayette Square, slaves, for the most part, lived in the townhouses. While Susan and Stephan Decatur did not register as slave owners, slaves were living in the house by the 1820s, when a servants' wing was added to the back. Many of the larger houses in Washington at the time would have had servants' wings like this, but the one at the Decatur House is believed to be the last remnant of what is known as an "urban plantation." Along with space for beds, preservationists have uncovered a kitchen hearth large enough to serve the entire household. The informational placard displayed in the Decatur House says, "Less than 150 yards from the White House, it remains a symbol of the clear and close

presence of slavery in the landscape of the American presidency." As many as twenty-five slaves may have lived in the house in the late 1830s, when it was owned by hotel operator John Gadsby—more on that later.

The White House Historical Association highlights three incidents involving slaves and Lafayette Square on its website.

In 1810, the area that became known as Lafayette Park was no more than open land north of the White House with the designation President's Park. Other than the White House, no buildings surrounded the park. Residents used it as a gathering place, and enterprising slaves grew fruits and vegetables on small plots of land that they could sell for their own benefit. One of these was Alethia Browning Tanner. Through her hard work and thriftiness, she slowly amassed the $1,400 needed to buy her freedom. That's not an inconsequential sum of money. According to an inflation calculator, $1,400 in 1810 would be equal to $26,158 today. But she didn't stop with her own freedom. She kept growing and selling fruits and vegetables until she had purchased the freedom of other family members.

In a growing urban area such as Washington, it was not uncommon for slaves to do side work to purchase their freedom, according to the historical association. A few petitioned the court for their freedom, and some ran away. That gave Washington a sizable population of free African Americans that exceeded the number of slaves before the Civil War. They created a vibrant society of their own. Tanner's nephew John F. Cook Sr. founded the Fifteenth Street Presbyterian Church as the city's first black Presbyterian minister. A school founded in the church's basement after the Civil War was among the first to educate African American high school students. It went on to become the M Street School, and among its graduates was Charles Hamilton Houston, who fought segregation battles in the early twentieth century and founded Howard University's law school. That, says the historical association, links Aletha Tanner's vegetable garden in Lafayette Park to the end of segregation in the United States.

The second story the historical association highlights brings us back to the Decatur House and the plight of an enslaved woman by the name of Charlotte Dupuy. After the death of her husband, Susan Decatur rented the mansion to prominent government officials. One of them was Henry Clay, who lived there while he was John Quincy Adams's secretary of state. Clay, known as the Great Compromiser, was one of the most influential political leaders in the nation's capital from the 1810s to his death in 1852. Born in 1777, he established his law and political career in Lexington, Kentucky. He was elected twice by the state legislature to the

U.S. Senate to fill unexpired terms, the first time in 1806, before he even met the constitutionally mandated minimum age of thirty. He was overwhelmingly elected to the U.S. House of Representatives in 1810 and was so popular that he was immediately elected Speaker of the House, where he was an advocate for fighting the British in what became the War of 1812. He was one of the negotiators of the treaty ending the war, pushing the British for more and more concessions as the fighting began to turn against them. He returned to the House as Speaker and ran the first of three times for president in 1824. When Adams won, he was appointed secretary of state and moved into the Decatur House. All of this indicates that Clay was not an inconsequential person in his dispute with Charlotte Dupuy.

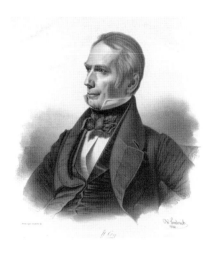

Henry Clay of Kentucky—House Speaker, senator, secretary of state and three-time presidential candidate. *Library of Congress.*

Dupuy insisted that her previous owner had promised her and her two children their freedom before he sold them to Clay. She sued Clay, insisting he had to uphold that agreement. The suit gained quite a bit of press interest. When it was not settled before Clay's term as secretary of state ended, the court ordered that she stay behind in the Decatur House, where she worked for wages for Martin Van Buren as the Peggy Eaton affair swirled around him. Clay took Dupuy's husband and children to Kentucky. When Dupuy lost the suit, she was forcibly taken to New Orleans to serve Clay's daughter. Clay sent Dupuy's daughter to be with her but kept her son and husband. Later, she came to Clay's Kentucky estate, where in 1840, eleven years after her suit, he freed her and her daughter but kept her son in his service for another four years. Clay had become a leader of the Whig Party that advocated a greater federal role in the nation's development and opposed the Democratic Party's reliance on states' rights. He became a leader in the Senate and was instrumental in forming the Compromise of 1850 that kept the Union together for another decade. The young Abraham Lincoln admired Clay greatly, crafting his political and economic philosophy around Clay's. Clay called for a gradual emancipation of the slaves, a position that Lincoln held until the Civil War.

The third story was written for the White House Historical Association by Pamela Scott, who got it from a story written in the *New York Express* in August 1850. It involves a coachman who served three presidents: James K. Polk, Zachary Taylor and Millard Fillmore. William Williams was well known and liked around Lafayette Square. As the Compromise of 1850 ended the slave trade in the District of Columbia, some slave owners wanted to move their slaves out. This became known as the "slave stampede," as some enslaved people fled for freedom before they could be shipped south while others were forcibly removed by their owners. While Williams had purchased his own freedom, his wife, children and grandchildren were still owned by a person living in New Orleans, who wanted them back. A Baltimore slave trader by the name of Joseph S. Donovan appeared one day and rounded up the family to take them to Baltimore in preparation for being shipped south. Williams was devastated. According to the newspaper story, "The poor man wrung his hands, rolled on the ground, was nearly crazed in fact, by the dreadful parting."

President Fillmore gave him money to go to Baltimore to see his family one last time. When he got there, he learned the slave trader was willing to sell him his family for $3,200, far more money than Williams had. When word got back to Washington, many of the neighbors in and around Lafayette Square took up a collection. Led by President Fillmore, contributors included Senator Daniel Webster and General Winfield Scott, as well as other senators. William Corcoran, the city's legendary philanthropist who lived on the square, gave $200, which immediately paid the price of Williams's aged wife. He also purchased one of Williams's daughters, who had lived with his family for several years. Georgiana Patterson, the widow of a navy commodore, and Sophia Towson, the widow of an army general, each contributed enough to purchase a daughter who had worked for them. Colonel William Bliss, President Taylor's son-in-law, loaned Williams the last $100 he needed of the $1,500 required to redeem his grandchildren.

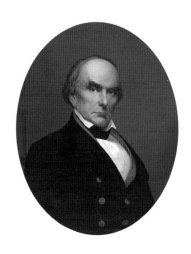

Daniel Webster of Massachusetts—House member, senator and secretary of state for three presidents. *Library of Congress.*

Was the newspaper account accurate? Pamela Scott tracked down the bill of

sale between Williams and Donovan dated August 13, 1850. It states that Williams bought five slaves: his wife, Dolly; daughter Susan Johnson; and her three children, ranging in ages from three to six, for $1,850. The bill also lists a second daughter, Maria. The rest, apparently, is lost to history. What is confirmed, however, is that it's good to know people in high places and to be well liked in Lafayette Square. On October 24, 1850, while Williams's family was reunited in Washington, ninety-three other less fortunate enslaved people were shipped from Baltimore to New Orleans aboard the ship *John C. Calhoun*.

Another story about slavery and Lafayette Square comes from Montpelier, the estate of James Madison, the fourth president, and his wife, Dolley. Montpelier is a beautiful home on grounds that roll through the Virginia Piedmont. It was there that a slave by the name of Paul Jennings was born in 1799. When the Madisons moved into the White House in 1809, Jennings was with them. In his reminiscences written in 1865, Jennings recalled the White House of that time: "The east room was not finished, and Pennsylvania Avenue was not paved, but was always in an awful condition from either mud or dust. The city was a dreary place."[27] Of course, this was the same time that Alethia Tanner was gardening and selling her vegetables across the street.

During the War of 1812, the British army marched on Washington in August 1814, when Jennings was fifteen. As the president rode off to inspect the city's defenses, Jennings helped Dolley pack up valuables from the White House in preparation for fleeing. For a long time, Dolley was credited with taking down the famous portrait of George Washington that hung in the East Room, but in his reminiscences, Jennings gave the credit to others: "It has often been stated in print that when Mrs. Madison escaped from the White House, she cut out from the frame the large portrait of Washington and carried it off. This is totally false. She had no time for doing that. It would have required a ladder to get it down....John Susé (a Frenchman, then the doorkeeper), and Magraw, the president's gardener, took it down and sent if off on a wagon....When the British did arrive, they ate up the very dinner, and drank the wines &c, that I had prepared for the President's party."[28]

When President Madison left office in 1819, he and Dolley and their slaves returned to Montpelier. Jennings married and started a family. He remained the president's valet and was with him at the time of his death in 1836. The president had purchased a house in 1828 on Lafayette Square at the corner of what is now H Street and Madison Place. It was built by Samuel

Daguerreotype of Paul Jennings as a free man. *Courtesy of the Sylvia Jennings Alexander Estate.*

Cutts, who had married Dolley's sister and had fallen on hard times. In 1837, Dolley, now a widow, moved into the Lafayette Square house, forcing Jennings to leave his wife and five children at Montpelier to come with her. Dolley left the management of Montpelier to her son by her first marriage, Payne Todd. Unfortunately, Todd's gambling and alcohol addictions, as well as his mismanagement of the estate, nearly bankrupted Dolley. She kept her lifestyle afloat by selling Madison's papers to the federal government and finally, in 1844, Montpelier with its slaves.

In her will written in 1841, Dolley promised to free Jennings, the only slave she promised to liberate. But her financial straits deepened in her final years. She rented Jennings to President Polk, keeping the proceeds for herself. Jennings began to fear that Dolley would not free him, which proved to be correct. In 1846, she sold him to an insurance agent in the city for a mere $200. That's when it was good to have friends in the neighborhood. Daniel Webster, the same legendary senator and secretary of state from Massachusetts who would later help William Williams buy his family's freedom, lived across H Street when Dolley Madison moved to Lafayette Square. He arranged to purchase Jennings for $120, and after Jennings had worked off that amount at $8 a month, Webster granted him his freedom.

Jennings went on to be a leader in Washington's free black community. Shortly after he attained his freedom, he helped organize an ill-fated attempt of a mass escape of seventy-seven slaves aboard the schooner *Pearl.* He returned to Virginia in the 1850s to reunite with his family. Three of his sons escaped during the Civil War and joined the Union lines. Jennings's book of reminiscences is considered the first White House memoir. He worked for the federal government after the war and bought a house on L Street, about four blocks from Lafayette Square, where some of his children joined him.

Now back to the Decatur House and the story of John Gadsby, a man who seemed to be in the right place at the right time throughout much of the early history of the United States. The question is, what was his role in buying and selling human beings? And did he do that right at the Decatur House within sight of the White House? The exhibit at the Decatur House refers to Gadsby as "a Virginia hotelier and slave broker who purchased Susan Decatur's home in 1836 after she lost it to creditors." Gadsby's tavern and museum in Old Town Alexandria, Virginia, is still a tourist attraction and restaurant that hosts a dance every February where people dress in eighteenth-century costume and dance the minuet in honor of

George Washington. Liz Williams, the tavern's director, has done a lot of research on Gadsby and on the role of slavery in the hospitality business before the Civil War.

Born in England and immigrating to the United States, Gadsby "had his fingers in" many major events in the United States from the Revolution to his death in 1844, Williams said. He arrived in Alexandria just as it was turning into a major port and operated the tavern that attracted George Washington, Thomas Jefferson, John Adams, James Madison, James Monroe and the Marquis de Lafayette. He moved to Baltimore in 1808, just as it was growing into one of the country's major ports. He ran the Indian Queen Hotel, one of the largest in the city; after the Battle of Fort McHenry in the War of 1812, Francis Scott Key stayed there while completing his poem "The Star-Spangled Banner." Moving back to Washington, Gadsby took over the Franklin House, which had been owned by William O'Neale, the father of Peggy Eaton, who, as we just learned, was the center of the "Petticoat Affair." There, Gadsby entertained Lafayette again during the marquis' 1824 visit to the city when the park was named in his honor. It's also where Jackson stayed during the fight over the 1824 election. Gadsby then took over the National Hotel, the largest in the District, where Jackson stayed in the days leading up to his 1829 inauguration and where the president retreated when the party at the White House got out of control.

"Once you put all of these events in a timeline, it's pretty stunning how much he saw in the course of his hospitality career," Williams said.

But what about the slaves? From her research into the use of slaves in the hospitality business, Williams knows it took a lot of their labor to run a large hotel. If there were as many as twenty-five slaves living at the Decatur House when Gadsby was running his downtown D.C. hotels, it would not surprise her. And no doubt to maintain this workforce, he would have to buy and sell a lot of people. But to call him a slave trader is something else again. That connotes that his main business was trafficking in slaves, and there were many people who did that in the District and Alexandria. But to do it, one would have to advertise a sale. Williams says she has gone through all the newspapers she could find from Washington and Alexandria looking for ads posted by Gadsby offering slaves for sale. Nothing.

One mystery did pop up in her research. When Gadsby died, he left a list of his slaves as part of his will. There are seventeen names with ages listed ranging from fifty to six months. Among the names is Rosa Marks, forty-eight. If you go to the Congressional Cemetery and find the Gadsby vault,

Williams said, you will see his name, his wife and some of the children. But also entombed there with the family is Rosa Marks. "I suspect Rosa was one of the daughters of the nursery staff," Williams said. "It's a mystery since she clearly was important to the family somehow. There's a lot more to be discovered."

On the opposite side of the park from the Decatur House, a congressman who was a protégé of Martin Van Buren shot dead the son of Francis Scott Key in broad daylight in front of several witnesses. Would he get away with it? That's for the next chapter—and Peggy Eaton makes a cameo appearance.

MURDER IN BROAD DAYLIGHT

Dan Sickles came out of the same political organization that Martin Van Buren had nurtured and promoted: New York's infamous Tammany Hall. By the time he astounded his neighbors by moving into an expensive town house just down Jackson Place from the Decatur House, the first-term congressman had mastered the art of the political deal and acquired a young and beautiful wife. He was a man with large appetites for power, for women and for money. And he had the charm, wit and charisma with both men and women to get them. He had few scruples, and the chances that he was a regular attendee at St. John's Church were slim. With the help of some of his powerful friends, he got away with murder in broad daylight, in the middle of Lafayette Park and in front of several witnesses. And he didn't kill just anyone. His target was the district attorney for Washington, D.C., and a man of equal charm and social standing: Philip Barton Key, the son of Francis Scott Key, the immortal author of "The Star-Spangled Banner." Dan Sickles and Barton Key were good friends—until they weren't.

Much of this account is taken from Thomas Kenneally's biography *American Scoundrel: The Life of the Notorious Civil War General Dan Sickles*. While Sickles's actions as a Union general at the Battle of Gettysburg were controversial, nothing touched the brazenness of what happened in Lafayette Park

Born in 1819 to a wealthy family of Dutch heritage in New York City, Sickles studied law with his eye on a career in politics. He made his first political speech at the age of seventeen at a rally in Brooklyn in support of Martin Van Buren's presidential candidacy and studied for the bar in

the law offices of Benjamin F. Butler, who had been Van Buren's law partner as well as attorney general in Andrew Jackson's administration. Sickles also was being groomed by New York's political machine, known as Tammany Hall, which had spotted his leadership potential at an early age.

Dan Sickles. *Library of Congress.*

Tammany Hall was the progenitor of urban political machines. Founded in 1786, it was used in the late 1790s by Aaron Burr to organize the city's politics in favor of himself and by Thomas Jefferson in the 1800 presidential election and to counter the political power of the Federalists and Alexander Hamilton. By the 1850s, it had become a political powerhouse by being the champion for Irish immigrants, arranging for them to become voting citizens as soon as they arrived, and by doling out political patronage. By 1854, it had elected its first mayor, saloonkeeper Fernando Wood, and its candidates for state offices from the city usually won. With a network of judges, politicians and beholden government officeholders, Tammany Hall played fast and loose with New York State politics.

Sickles's Tammany association helped gloss over allegations of financial chicanery and voting irregularities, as well as Sickles's appetite for women. Among them was a prostitute by the name of Fanny White, who became an obsession with him that was not well hidden. Despite all of this, with the help of Tammany, he was elected to the state assembly in 1847. He even took Fanny to Albany and introduced her around, giving her a tour of the assembly chamber, which earned him a censure from the Speaker. That didn't even register as a setback, as he was elected as a delegate to the 1848 Democratic convention and continued to build a network with the national party organization. Nor did it stop him from courting a teenager by the name of Teresa Bagioli.

Sickles had known Teresa and her family since she was an infant. Her father was an opera maestro and Italian immigrant. Her mother lived with an Italian family much admired by Sickles. By the time she was eight, the young Teresa already was enamored with the much older Sickles. At fifteen,

she was described as a beautiful, brilliant and outgoing young woman. The thirty-two-year-old Sickles was more than twice her age but smitten. They married in a civil ceremony at city hall on September 27, 1852. Was she pregnant at the time of marriage? No one is quite sure. But she was certainly showing when they held a church ceremony in March. The two, by all accounts, were quite in love. However, the marriage certainly did not stop Sickles from his extracurricular activities, much to the adolescent Teresa's dismay. But he was a good provider, and his Tammany connections earned him the plum job of corporation attorney for the City of New York. This gave him a large retainer and a chance to earn fat legal fees. He even was one of the prime advocates for the construction

Teresa Baglioli Sickles. *Library of Congress.*

of Central Park, as well as New York's horse-drawn transit system.

Just before his marriage to Teresa, Sickles was a delegate to the 1852 Democratic convention and enthusiastically supported the nomination and election of Franklin Pierce. As a reward, he was appointed first secretary to the American legation in London, the number-two position under the ambassador to the Court of St. James, James Buchanan. Buchanan already had been a secretary of state to both Presidents Jackson and Polk, as well as an ambassador to the Court of St. Petersburg in Russia and a U.S. senator. His ambition to be elected president in 1852 had been thwarted by Pierce. But his connections throughout the nation's Democratic establishment were vast. Indeed, he would be elected president four years later, mostly because he had been out of the country during the tumultuous years as the country began to split apart and therefore was not responsible for anything that had happened.

Teresa did not accompany Sickles as he left for London. With their daughter, Laura, so recently born, she did not want to risk her health on an ocean crossing, and she wanted to stay close to her mother. That seemed to be okay with Sickles. He took Fanny White instead. She may have been on the same ship that Teresa waved off from the Port of New York. Buchanan

was willing to turn a blind eye to Fanny's presence, and in early 1854, Sickles gave in to Fanny's entreaties to meet Queen Victoria. "Dan had been rash enough to take Fanny to a royal reception at Buckingham Palace, at which he passed her off to the Queen and Prince Albert as Miss Julia Bennett of New York. Thus, the proprietor of a fashionable New York bordello took the hand of, and executed a curtsey toward, the monarch of Great Britain and the arbiter of strenuous moral ambitions for an entire empire, even for those lost sections now incorporated into the United States of America."[29] When Teresa arrived in London in the spring of 1854, Fanny disappeared back to New York. Sickles's young wife became a hit in London society and a favorite of the bachelor Buchanan and his niece Harriet Lane, who was five years older than Teresa and served as the legation's hostess. Buchanan even appointed Teresa as official hostess when Harriet had to return to the United States. Leaving his post after two years, Sickles returned to New York and immediately started to work on Buchanan's presidential campaign and to run as Tammany's candidate for the state senate.

Not only did he get some credit for helping to elect the president, Sickles also quickly gave up his state senate seat to win one in Congress. The Sickleses were headed to Washington. The first-term congressman leased a house at 722 Jackson Place that since its construction in 1820 had been the home of a Supreme Court justice, a former secretary of the treasury, an attorney general, a secretary of the navy and a secretary of the treasury. At the time the Sickleses rented it, the house was owned by Anna Stockton, one of Stephen Decatur's favorite nieces who had been living in the Decatur House on the day the commodore was shot. Whispers on Capitol Hill and around the District wondered how the first-term House member could afford such a house. "A powerful and unnamed set of financial, manufacturing, and transport interests in New York wanted Dan to have a house of this nature—one commentator believed the entire costs were absorbed by a New York steamship company whose executives frequently visited."[30] Not only was the house lavish, but the Sickleses' coaches were said to be among the finest in Washington, and Teresa's jewelry was dazzling.[31] The Sickleses entertained lavishly. "Teresa held receptions on Tuesday afternoons, and the couple staged weekly dinners on Thursday nights for invited guests. To Teresa's at-homes came the eminent women of Washington, together with sundry officials and bureaucrats. Though young, she spoke to them as a peer, and they were impressed that she possessed the complex gifts required to maintain a fine house, a corps of servants, and a good dinner table."[32] Among the guests was their old friend, now president, Buchanan, and

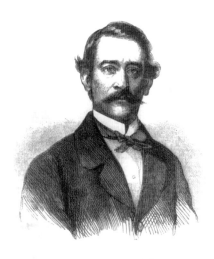

Philip Barton Key. *Library of Congress.*

Teresa renewed her friendship with Harriet Lane, who assumed the duties of official White House hostess in the Buchanan administration. In the social whirl of official Washington, Teresa spent many of her afternoons driven in her coach to receptions held by the wives of other legislators.

Teresa captured the eye of Philip Barton Key, known as Barton to his friends. At thirty-nine, he was a recent widower with four daughters who were being raised by a relative. His status in Washington society was impeccable. Coming from a long line of prominent Marylanders, his father was Francis Scott Key, the district attorney for Washington who wrote "The Star-Spangled Banner" while trying to free a prisoner being held by the British aboard a ship during the assault on Fort McHenry. His uncle was Roger Taney, now the chief justice of the United States after serving as secretary of the treasury, attorney general and secretary of war, all in the Jackson administration. Key had followed his father as Washington's district attorney, where he reportedly did not work particularly hard, and, since the death of his wife, had become one of the most eligible bachelors in Washington social circles. Virginia Clay, the wife of an Alabama senator, wrote that Key was "the handsomest man in Washington society....A graceful dancer, he was the favorite of every hostess of the day. Clever at repartee, a generous and pleasing man, who was even more popular with other men than with women."[33] Here is where Peggy Eaton makes another appearance. When Key displayed more than a casual interest in her daughter Ginger, a popular debutante, Peggy "was reported to have locked up Ginger to prevent her from running away with Key."[34] If Peggy Eaton's daughter was a debutante, Peggy must have rehabilitated her place in Washington society twenty years after she had torn it asunder.

At President Buchanan's inaugural ball, Barton Key met Teresa Sickles.

Dan Sickles and Key also became friends; Key helped Sickles close the deal on the Stockton mansion. They both were frequent patrons of the Washington Club, a thirty-room mansion directly across the park

from the Sickleses' new home that had been converted into a private fashionable watering hole for Washington's elite men. It was known as "a drinking and gambling place patronized by the young bloods of the town."[35] Sickles even encouraged Key to escort his wife to social events when he was not available. But the relationship between Teresa and Key quickly grew to something more. Key would ride alongside Teresa's carriage when she was out for a ride. Soon he was attaching his horse to the carriage as he rode inside. They progressed to meeting in remote places such as cemeteries away from prying eyes, and even in the parlor of the Sickleses' home. At the height of the affair, Key rented a small house on Fifteenth Street near Lafayette Park where they would meet. Key developed a habit of coming out of the Washington Club into the park near the Jackson statue and waving a white handkerchief. If Teresa was available, she would signal back.

While it is true that Sickles was spending a lot of time on Capitol Hill pushing the Buchanan agenda, he also was conducting affairs of his own. He often would take a train to Baltimore, where he would meet a woman from Philadelphia for a clandestine tryst at Barnum's Hotel. And she was not the only one. "He was able to attract women of respectable background, only a few of whose names we know. Fixing a woman with his intense, glittering eye, he would utter all of the requisite imagery of a desperate lover."[36] Some people thought Sickles must have known about his wife's affair and perhaps did not object. But apparently, he did not

Dan Sickles's assault on Francis Barton Key drew national press attention. This engraving from the time depicts the crime. Standing aside nonchalantly is Sam Butterworth, who was a friend to both men. *Library of Congress.*

know. For his part, Key dismissed people who objected to his affair, saying he only had fatherly concerns for a young woman. And that's where things stood in late February 1859, when someone known only as R.P.G. wrote a letter to Sickles detailing his wife's affair with Key. The letter was written in a woman's hand, and some have speculated that R.P.G. was Rose O'Neal Greenhow, a southern lady who had befriended Teresa but who also had designs on Key. Living just off Lafayette Square, she later would become a notorious Confederate spy.

It took a couple of days for Sickles to ascertain the truth of the letter. When he did, he confronted Teresa, who broke down and admitted everything. He forced her to write a detailed confession. And he himself broke down and wept bitterly, distraught that not only had his sweet, beautiful young wife betrayed him but that everyone in town seemed to know about it. He felt himself disgraced personally, socially and politically. So, that probably was not a good day for Key, taking advantage of the warming temperatures after a cold snap, to try to signal a meeting with Teresa, even though he had a letter in his pocket warning him that people knew about his affair. He hung out at the Washington Club, looking for the right time to signal Teresa. Several people saw him walking around the park, waving a white handkerchief and looking for a response from Teresa. Instead, it was Sickles who saw him.

As Key talked with Sickles's friend Sam Butterworth, just outside the Washington Club, the congressman, wearing a heavy coat, slipped out of the basement level of his house and circled the park along H Street so he could cut off any chance that Key would retreat into the club. In front of several people in the park, Sickles shouted, "Key, you scoundrel, you have dishonored my house—you must die." He drew a derringer from his overcoat pocket and fired. That shot did little damage to Key, who jumped at Sickles as he prepared to fire again. As the two grappled, Sickles dropped that gun, but when he pulled away, he drew another one out of his coat. As Key backed up Madison Place toward the Washington Club, he cried, "Don't murder me." Reaching into his own coat, he pulled out some opera glasses and threw them at Sickles. The second shot hit Key in the upper leg. "I'm shot," Key said. He begged Sickles not to shoot again, but Sickles kept yelling insults at him, saying Key had dishonored his marriage. Key dropped to the ground, crying, "Don't shoot me. Murder! Murder!" Another shot misfired, but Sickles re-cocked the gun, held it close to Key and fired again. This shot was fatal, and still Sickles tried to fire again with another misfire. By then, witnesses began to intervene. Butterworth,

Image of Dan Sickles in prison as it appeared in the popular press. *Library of Congress.*

who had been standing by—depicted in an engraving as leaning against a tree watching the action—stepped in. "He has violated my bed," Sickles said repeatedly to justify his action.[37] Key's body was carried into the club, where it lay on the floor during the coroner's inquest.[38]

Was this murder? Or was it the act of a distraught man who had just learned that his wife was an adulteress with a friend, whom he had personally witnessed trying to signal her for another tryst? The newspapers were full of the story of the shooting and, subsequently, of the trial. Sickles's attorneys included Edwin Stanton, who would go on to be Lincoln's secretary of war. While Teresa's confession was not allowed to be introduced as evidence, it was printed in many newspapers. Also suppressed as evidence was proof of Sickles's own affairs, including the register at the Barnum Hotel. But the witnesses went through every detail of Teresa's affair. The defense noted that not only did Sickles befriend Key and welcome him to his house, but Sickles had intervened with President Buchanan to ensure that Key had been able to keep his position as Washington's district attorney. Key was portrayed as a man who had been sworn to uphold the laws and morals of the district but ended up violating them.

The defense had two different threads, sometimes contradictory. One was that Sickles was justified in shooting Key to avenge the affair and to uphold the sanctity of the home and marriage. The other was that the revelation of the affair and seeing Key trying to signal his wife had addled Sickles's mind, causing him to act with temporary insanity to commit the crime. Never before had temporary insanity been used as a legal defense. But in his instructions to the jury, the judge said, "It was for the jury to say what was the state of Mr. Sickles' mind as regards the capacity to decide upon the criminality of the homicide…the insanity of which the defense spoke need not exist for a definite period, but only for the moment of the act of which the accused was charged."[39] And the jury? Not guilty. So said them all.

It took only three and a half months after the death of Key for Sickles to reconcile with Teresa. While Sickles's acquittal had been widely lauded, his reconciliation was greeted by almost universal scorn. How could he take back a woman who had been so profligate? Sickles maintained his congressional seat, but he did not return to the Lafayette Park house. A major in the New York militia before the Civil War, he tried to repair his reputation by raising volunteer units in New York. A book could be written about his Civil War exploits, especially his role in the Battle of Gettysburg. Military historians are still arguing whether as a corps commander he nearly lost the battle or won it by moving his troops against orders on the second day. At the height of the Confederate attack, a cannonball mangled his right leg. After it was amputated, he donated the bones to the new Army Medical Museum in Washington that was looking for specimens of severed limbs. He famously visited every year on the anniversary of its amputation, and it can still be seen in the National Museum of Health and Medicine in Silver Spring, Maryland. Sickles won a Congressional Medal of Honor for gallantry in rallying his troops even after he was wounded, but he also is the only corps commander who does not have a statue on the battlefield. After the war, Sickles stayed in the army, commanding Union troops in the South during Reconstruction.

Back in New York, Teresa did not last long after the war. Coming down with tuberculosis, she was a near invalid by the autumn of 1866. In January 1867, she came down with a pulmonary infection that hastened her decline. Summoned by telegram, Sickles rushed back and arrived in time for her funeral on February 9. She was thirty-one. Sickles himself lived to the age of ninety-four. President Grant appointed him minister to Spain, and keeping up with his old habits, he apparently had an affair with the deposed Spanish queen, Isabella II, while at the same time

courting Caroline de Creagh, a beautiful young woman of Spanish Irish background. They had two children while Dan Sickles was, well, Dan Sickles.

Back in Lafayette Square, the mayhem continued with an assassination attempt just a few feet from where Sickles shot Key. That story is for the next chapter.

Chapter 6

A SPY, A PRIG AND
AN ASSASSIN

The Civil War Comes to Lafayette Square

T he Civil War transformed Lafayette Square, as it did all of
Washington—and all of the United States. Some of the private
homes, including the Decatur House and Dolley Madison's house, were
taken over by the government for the war effort. One of the Confederacy's
most notorious spies—Rose O'Neal Greenhow—owned a house on
Sixteenth Street right across from St. John's Church where the Hay-Adams
Hotel now stands. That put her just a few steps from the headquarters of the
commanding general of the Army of the Potomac in the Dolley Madison
house. General George McClellan, who soon was elevated to be commander
of all the Union forces, moved in there with a room on the second floor. And
just two houses down from McClellan was the home of Secretary of State
William Seward. After the shooting of Barton Key and the breakup of the
Union, the Washington Club fell on hard times and was boarded up for a year.
When he joined the Lincoln administration, Seward sought a house where
he could entertain in style. The new owner of the Washington Club was only
too happy to remodel the thirty-room mansion to fit Seward's taste and rent
it to him at a reasonable cost. And, of course, in the White House, a restless
Abraham Lincoln often spent his evenings walking to the War Department,
to McClellan's house and almost constantly to visit Seward. At the height
of the rebellion, with spies and Southern sympathizers everywhere, Lincoln
would walk through the park unprotected, usually accompanied only by his
loyal secretary John Hay.

Let's start with the story of Rose Greenhow. Born about 1814 into modest means in rural Maryland, she came to Washington at the age of fourteen after her father died and her desperate mother sent her to live with an aunt and uncle. They ran a congressional boardinghouse across the street from the Capitol, and the high-spirited, beautiful young woman soon became a favorite of the clientele. Among the boarders was Senator John Calhoun, who instilled in her a fervent love of the South and states' rights. She attended parties and worked her way up in Washington society. She also became a favorite of Dolley Madison, visiting her in her Lafayette Square home, and tried to model herself on the former first lady's ability to influence powerful people. In 1835, Rose married Robert Greenhow, one of the top officials in the State Department, who was fourteen years her senior. That introduced her to even higher elements of Washington society. She became good friends with James Buchanan when he was secretary of state. Her niece and namesake, Rose Cutts, married Senator Stephen Douglas. She even developed friendships with Republicans, including Senator Seward and Senator Henry Wilson of Massachusetts. With four children, she and her husband lived for a while in San Francisco. But when he was killed after falling off an elevated sidewalk, Rose collected enough in damages and a congressional settlement to return to Washington and live in style. Buchanan, now president, became a regular at her house, sparking rumors.

"Soon Rose Greenhow was known as the go-to person for promotions or favors from legislators, army officials and government personnel," wrote historian H. Donald Winkler.[40] "She got results, and the people she helped became indebted to her."

After Lincoln's election and with the coming war, Rose decided to stay in Washington and use her influence to assist the Confederate cause. She was recruited as a spy by Colonel Thomas Jordan just before he gave up his commission in the U.S. Army to join the Confederacy. He gave her a simple twenty-six-symbol cipher code she could use to send messages to him. The most important information the Confederate army needed was the time and location for the Union's first major attack. Knowing that would allow the Confederates to mass their forces to meet the enemy. How would she get such detailed information? Perhaps from Senator Wilson, who now was both the chairman of the Senate Military Affairs Committee and her lover. In July, she sent Jordan Lincoln's order for the attack, McDowell's plan for it, the size of the Union forces involved and their route to Manassas Junction.[41] With that information, President Jefferson Davis was able to get a second corps to Manassas just in time to turn the battle. In the aftermath, Rose

continued to get information to the Confederates on the condition of the Union army and the defenses of Washington. Rose had expanded her spy network to forty-eight women and two men. So much detailed information was getting to the Confederates that General McClellan complained that the Rebels knew his plans better than Lincoln or the Cabinet.[42]

But the Federals were closing in on Greenhow. Allen Pinkerton was developing the Union's Secret Service, and on the night of August 22, while staking out Greenhow's house, he saw a Union officer enter it. Spying through the window, he saw the officer give Rose a map of the defenses of Washington. The two of them then disappeared to a back room for an hour. When they emerged, the officer left and Pinkerton followed him. Soon they both were in a dead run that ended when the officer ran into the provost marshal's office. Four soldiers ran out and arrested Pinkerton, who was hauled before the captain of the guard—the same person he had spied at Rose's house. When Pinkerton refused to identify himself or his business, the captain had him thrown in the brig. But Pinkerton got a message to the War Department. The next morning, Pinkerton was released and the captain arrested. Later that day, Pinkerton arrested Rose in front of her house. Hoping to ensnare some of her allies, he hustled her into the house as his men searched the home, finding plenty of incriminating evidence, despite Rose's attempts to hide and burn it. Rose's eight-year-old daughter scampered out the back door, climbed up a tree and shouted, "Mama's been arrested." Still, some of her agents stopped by the house and were arrested. Soon the house became a makeshift prison for female spies, and the press dubbed it Fort Greenhow. Yet Rose managed to get messages out, including a letter that was printed in a Richmond newspaper. Exasperated, the Union officers moved her and her daughter to the Old Capitol Prison that at one time had been the boardinghouse where she had learned her Southern leanings from Calhoun. She continued to taunt her guards and to get information out. Meeting before a military commission, she was asked what her sources of military information were. She responded, "If Mr. Lincoln's friends were to pour into my ears such important information, am I to be held responsible?"[43]

Federal officials decided Rose could never be tried for treason. She knew too much about too many people. Instead, they arranged for her to be sent south, where she was greeted as a heroine. Jefferson Davis sent her to Europe to win support for the Confederacy from the British and French. On her way back in September 1864, the blockade runner she traveled on was confronted by a Federal gunboat and ran aground. Despite the stormy

Rose Greenhow operated a Confederate spy ring out of her house on the north side of Lafayette Square. Here she is shown with her daughter after her arrest and imprisonment in the Old Capitol Prison. *Library of Congress.*

seas, Greenhow insisted that she be allowed to leave on a lifeboat with two of her fellow Confederates to try to avoid capture. The boat overturned, and Greenhow drowned, weighed down by $2,000 in gold sovereigns hidden in a belt around her waist.

At the very same time that Rose Greenhow was operating her spy ring, just half a block away, General George B. McClellan was setting up his headquarters in Dolley Madison's old house, where Rose had once gotten lessons in social etiquette from the former first lady. And the same Allen Pinkerton, who would be peering into Rose Greenhow's window, was developing estimates of the size of Confederate forces in Virginia for McClellan that were three times their actual size. McClellan insisted he could not confront the Confederate army in Virginia until he received massive numbers of reinforcements and instead spent his time training the troops he had and holding parades. He was much beloved by his soldiers, but his lack of action against the enemy put McClellan in conflict with his superior, the aged General Winfield Scott, and set back the Union war effort for more than a year. Lincoln tried mightily to mollify the two generals, and when Scott finally retired on November 1, 1861, Lincoln appointed McClellan as commander of all the federal forces. As thanks, McClellan referred to Lincoln in private as "the original gorilla," complained about his storytelling and said he was not fit to be president.

On Wednesday night, November 13, 1861, Lincoln, Seward and Lincoln's secretary John Hay went to McClellan's house. As historian Doris Kearns Goodwin described what happened, the visitors were told the general was at a wedding, and they decided to wait in the parlor for his return. When McClellan returned, his porter told him the president was waiting in the parlor. But the general walked past the parlor and climbed the stairs to his rooms. A half hour later, Lincoln again sent word that he was waiting, only to be told McClellan had gone to bed. To Hay, this "insolence of epaulettes" indicated that military authorities would try to supersede civilian control. But Lincoln took a more benign approach. He said he

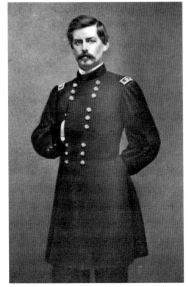

General George B. McClellan.
Library of Congress.

would hold Lincoln's horse, if victory could be achieved.[44] When McClellan did not produce victory, Lincoln fired him.

Lincoln and Seward's relationship—although begun on an equally rocky start—turned out to be far more congenial. Indeed, having Seward living just a few steps across Lafayette Park from the White House turned out to be beneficial to both men and to the survival of the Union. Seward and Lincoln had been rivals for the Republican presidential nomination in 1860, and Seward could not believe the party had turned to a man with practically no political or governing experience over him, who had been a senator and a party stalwart. When Lincoln appointed the senator from New York as secretary of state, Seward thought he would work behind the scenes as the prime minister with Lincoln as more of a figurehead. Lincoln quickly disabused him of that notion. By May 1861, Seward had come to admire Lincoln, calling him "the best of us" and becoming his most faithful ally in the Cabinet.[45] The gregarious secretary soon settled into what he liked best: using his mansion on Lafayette Park to host parties that served their own diplomatic and political purposes. "All the rooms were full, with dancing in one, drinks in another and good conversation all around. Seward was in 'excellent spirits' moving easily among Cabinet members, military officers, diplomats and senators."[46] Seward's wife was a semi-invalid and spent most of her time at their family home in Auburn, New York, coming to Washington on occasion to visit. The secretary lived in the Lafayette Square home with his son Frederick, who served as his assistant at the State Department, and Frederick's wife, Anna. Sometimes Seward's daughter Fanny stayed with them when she was not attending to her mother in Auburn.

Lincoln did not drink or smoke, as Seward loved to do, but many, many nights during his administration, he would amble across the park to visit Seward. This infuriated First Lady Mary Todd Lincoln, who never liked Seward and resented being left alone in the White House. But Lincoln enjoyed sitting with a fellow politician he could trust, swapping stories and talking strategy in a relaxed atmosphere. Their relationship blossomed and endured during the worst of the war years. Lincoln and Seward were the only members of the administration who loved the theater. Indeed, in March 1865, the great Shakespearean actor Edwin Booth—and brother of John Wilkes Booth—appeared in Washington, and both Lincoln and Seward attended several of his performances. On the evening of March 11, Seward entertained Edwin Booth at his home. Lincoln was sorely disappointed not to be able to join the evening.

And that brings us to the events of the last few days of Lincoln's life that have been seared into the national memory. While most any schoolchild can recite what happened to Lincoln at Ford's Theater, the similar drama that took place that evening at Seward's Lafayette Square home is less well known.

Victory and tragedy were developing simultaneously in and around the square. On the afternoon of April 5, as Lincoln was visiting the fallen Richmond, Seward, Frederick, Fanny and Fanny's friend Mary Titus set out for a carriage ride. When the carriage door kept swinging open, Seward asked the coachman to dismount and fix it. That startled the horses, which began to run. Frederick jumped out to try to

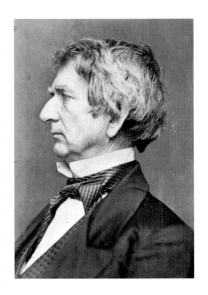

William Seward. *Library of Congress.*

stop them but fell to the ground as the carriage gained speed. Then Seward, thinking he could stop them, sprang out of the coach. Instead, he fell violently on his right side, breaking his arm close to his shoulder and fracturing his jaw on both sides. He was carried back to his house, and his doctors feared for his life. A cast was put on his arm, and his jaw was wired shut.[47]

By the time Lincoln returned from his visit to Richmond on April 9, Seward's condition had deteriorated, with a high fever along with the shock of the accident. Seward had been placed on the far side of the bed to relieve pressure from his broken arm. Lincoln rushed to Seward's third-floor bedroom and was shocked by the condition of the secretary of state. He lay down next to Seward and, speaking quietly, told him of what he had found in Richmond. When Seward fell asleep, Lincoln quietly left the room.[48]

The next morning, Washington was in jubilation when news of Lee's surrender reached the city. As Noah Brooks, a newspaper reporter at the time, wrote in his memoir, "Most people were sleeping soundly in their beds when, at daylight, on the rainy morning of April 10, a great boom startled the misty air of Washington, shaking the very earth, and breaking the windows of houses about Lafayette Square and moving the inhabitants of that aristocratic locality to say once more they would be glad when Union victories were done with, or should be celebrated elsewhere. Boom! Boom! Boom! Went the guns until 500 were fired."[49]

Meanwhile, John Wilkes Booth was meeting with his fellow conspirators at Mary Surratt's boardinghouse about ten blocks away. In his plot against Lincoln, Booth at first wanted to kidnap the president and try to force a deal for his release that would preserve Southern independence. For something that complex, he had recruited several co-conspirators. But with the fall of Richmond and the surrender of Confederate General Robert E. Lee at Appomattox, he soon realized that kidnapping Lincoln was futile. On the evening of April 11, with the city in euphoria, Lincoln spoke from a second-story window of the White House to a huge crowd that had gathered on the front lawn. As historian Doris Kearns Goodwin described the scene, among those assembled were Booth and two of his conspirators, drugstore clerk David Herold and former Confederate soldier Lewis Powell, also sometimes known as Lewis Payne. Lincoln talked about extending suffrage to blacks. Booth turned to Powell and said, "That means nigger citizenship. That is the last speech he will ever make." He asked Powell to shoot the president right at that moment. When Powell declined, Booth said, "By God, I'll put him through."[50]

Knowing that the president would be attending Ford's Theater on April 10, Booth hatched a plot where he would kill Lincoln at 10:00 p.m. At about the same time, George Atzerodt, a Port Tobacco, Maryland carriage repairman, was to kill Vice President Andrew Johnson at the Kirkwood House, a downtown hotel where the vice president was staying. And to Powell, Booth assigned the task of killing Seward. With three of the most important Federal leaders dead, Booth figured, the Union would be in disarray and Booth would be welcomed as a hero in the South.

General Ulysses Grant, the hero of the hour, and his wife were invited to join the Lincolns for the evening performance. When they begged off, the president invited Major Henry Rathbone and his fiancée, Clara Harris. Rathbone lived at 722 Jackson Place. So, the last stop Lincoln made on his way to Ford's Theater was on Lafayette Square.

Booth, of course, was successful. Atzerodt got drunk and lost his nerve. That left Powell.

Lewis Thornton Powell was born in Randolph County, Alabama, in 1844. His family migrated to Florida, and at the beginning of the war, Powell enlisted in the Second Florida Infantry. By the Battle of Gettysburg, he was a battle-hardened veteran, and he was wounded just before Pickett's Charge. Escaping from a prisoner of war hospital in Baltimore with the help of a sympathetic nurse, he headed south to join Mosby's Rangers, a group of Confederate irregulars that raided Yankee

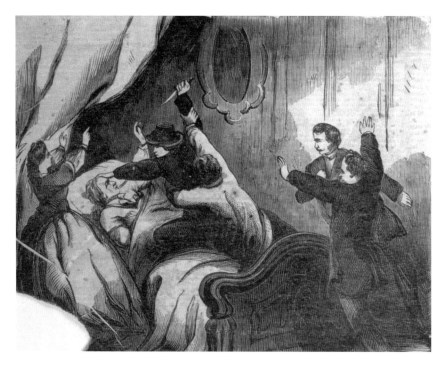

Engraving depicting Lewis Powell's assault on William Seward. *Library of Congress.*

supply lines in Northern Virginia. On January 1, 1865, seeing that the war was lost, Powell deserted the Confederate army. In late January or early February, Powell met Booth in Baltimore. Booth took an instant liking to the six-foot, tough Powell. He needed someone like that if he was going to kidnap Lincoln. Powell soon became an acolyte of Booth's, quickly becoming a key lieutenant in the conspiracy.

On the evening of April 14, Powell and fellow conspirator David Herald waited in the shadows of Lafayette Park for the appointed time for the attack. They knew of Seward's accident, which meant he would be at home. At 10:00 p.m., Powell knocked on the door and told the servant he was sent by Seward's doctor to deliver some medicine, pointing to a small package he had brought as a prop. He insisted that he had to deliver it to Seward personally, and when the servant protested, he pushed past him and headed up the stairs. But which of the many rooms was Seward's? In his biography of Seward, Walter Stahr described what happened. At the top of the stairs, Powell met Seward's son Frederick, and again he insisted he had to deliver the package directly to Seward. Fanny was in

Seward's room with a male nurse named George Robinson. Hearing the commotion in the hall, and thinking it could be the president, she went out. Powell asked, "Is the secretary asleep?" Fanny looked back into the room and said, "Almost." Now Powell knew where Seward was. He turned as though he were leaving but then turned back with a navy revolver in his hand. He pointed it at Frederick and pulled the trigger. When it misfired, he crashed the butt onto Frederick's head, nearly killing him, and rushed into Seward's room with the pistol in one hand and a bowie knife in the other. Robinson grabbed at Powell, who slashed him with the knife and pushed him to the floor. Fanny screamed, and Seward awoke with a start, rising himself up with great effort to try to defend Fanny. Powell jumped on him, pressing him into the bed with one arm and stabbing down on him with the other, over and over, cutting Seward's face and neck. Robinson tackled Powell as Seward's other son, Augustus, joined the fight, pushing Powell out into the hall. He looked Augustus in the eyes and said, "I'm mad, I'm mad," then rushed down the stairs and out of the house. Fanny ran back into the room and found her father in a pile of bloody sheets. "Oh my God! Father's dead!" she screamed.[51]

But Seward was not dead; in fact, he may have been saved by the cast on his arm and the wire holding his jaw together. But he was terribly disfigured. While Booth was shot by Federal troops pursuing his escape and Powell was hanged with the other conspirators, Seward remained as secretary of state during Andrew Johnson's administration, gaining fame by buying Alaska from the Russians for $5 million, a treaty that he signed in the Lafayette Square house. After traveling the world, he returned to his home in Auburn, New York, which is open for public tours. He died there in 1872. The Sewards kept everything, the guide at the house said, including the bloody sheets from the assassination attempt.

The Lafayette Square house was torn down in 1894 to make way for the Lafayette Square Opera House, later the Belasco Theater, that attracted some of the biggest-name entertainers of the early twentieth century. Today, that theater is long gone, replaced by a modern office building now known as the Howard T. Markey National Court Building. It looks like the type of building that Jackie Kennedy was trying to stop from ruining Lafayette Park. If you walk through the arched entryways into the building's courtyard, you can see historic plaques attesting not only to the assassination attempt but also to all of the famous people who lived here when it was a residence. Walk to the left, and you can see the backs of the other historic homes on Madison Place. It's kind of an atrium-enclosed glimpse of the past.

Lewis Powell, Seward assailant, after his arrest. *Library of Congress.*

Next, we follow the story of Lincoln's secretary, John Hay, and Henry Adams, great-grandson of a president, grandson of a president and son of the minister to Great Britain during the Civil War. He, too, knew Seward well. Hay and Adams became such fast friends that they built adjoining mansions on the north side of Lafayette Square, tearing down the house where Rose O'Neal Greenhow ran her spy ring to make room. But all is not happiness for the two families.

TRAGEDY OF THE FIVE
OF HEARTS

The Hay-Adams is an unusual name for a hotel. Since 1928, it has defined luxury accommodation in Washington, where it anchors the north side of Lafayette Square. Its front door faces Sixteenth Street and St. John's Church. Its broad south-facing wall faces H Street, the park and across the park to the White House. It rooftop offers a commanding view of the president's home. How the Hay-Adams got its name is an unusual story of an amazing friendship, a tragic loss and the apogee of Lafayette Square as a residential neighborhood that defined Washington society at the time that the United States blossomed into a world power politically and culturally.

We start with John Hay, President Lincoln's young secretary, who, as a new graduate of Brown University studying law in Illinois, met and befriended the aspiring president. At the age of twenty-two, Hay came with Lincoln to Washington as one of the new president's two main secretaries. Throughout the Civil War, he lived in the White House and accompanied Lincoln everywhere, including his evening trips across Lafayette Park to visit Secretary of State Seward. On the night of April 14, 1865, Hay was talking with Lincoln's son Robert in the White House when people burst in shouting the president had been shot. The two flagged down a carriage for a dash to Ford's Theater, and Hay was with the president the next morning when he died at the Peterson house across the street. Distraught, he accepted a minor diplomatic post in the American embassy in Paris. For five years, he jumped from post to post in Europe, complaining bitterly about the

European officials he met as well as the American politicians who had replaced Lincoln. Returning to the United States in 1870, he, by chance, landed a position at Horace Greeley's *New York Tribune*, where he soon distinguished himself not only by his knowledge of European diplomacy but also by his dogged reportorial work. He covered the Great Chicago Fire, even interviewing Mr. O'Leary, whose cow started the conflagration. For a short time, a doggerel poem he wrote, "Jim Blodsoe of the Prairie Belle," achieved as much acclaim as anything Bret Harte or Mark Twain, who had become his friends, were writing at the time. By age thirty-five, Hay was a successful writer and

John Hay, who rose from Abraham Lincoln's secretary to William McKinley's secretary of state. *Library of Congress.*

newspaperman on top of his diplomatic and White House credentials. That's when he married Clara Stone, the daughter of a Cleveland bridge builder and financier. How could she resist a man who wrote that she was "radiant and glorified with some divine beauty and promise—until it seemed to me that I could not live without falling at your feet and pouring out my full heart in worship."[52] She also brought to the marriage a large fortune. For a while, the Hays lived in Cleveland, where John worked for his father-in-law while collaborating with John Nicolay, the other White House secretary, on their ten-volume biography of Lincoln. But in 1879, at the request of President Rutherford B. Hayes's secretary of state, William Evarts, Hay returned to Washington as an assistant secretary of state, filling in for his friend, the departing Frederick Seward. Hay found much of this work disagreeable, but one thing he came to love was his new friends Henry and Clover Adams and their house on Lafayette Square.

For Adams, all of Washington society gathered around Lafayette Square, and beyond it, "the country began."[53] Adams's pedigree is impeccable. He was the great-grandson of the Revolutionary leader and second president, John Adams, and the grandson of John Quincy Adams, the sixth president. His father, Charles Francis Adams, had run as a vice presidential candidate for the Free Soil Party—the precursor of the Republican Party—with Martin

Van Buren in 1848. He served a term in Congress before Lincoln named him ambassador to Great Britain, and he is often credited with keeping the British from recognizing the Confederacy. Henry Adams was born in 1838, the fourth child in the family. Like his father, grandfather and great-grandfather, he attended Harvard, but he was at loose ends after graduating in 1858 and traveling in Europe and studying in Germany. He accepted his father's offer to become his personal secretary in London during the Civil War. He secretly wrote articles for London newspapers, which taught him how much he loved writing and journalism. When his father returned to the United States in 1868, Henry decided on a career in journalism and went to Washington. Because of his name, doors opened for him all over town, and he lambasted the corruption in the Grant administration and in Congress. "To be abused by a senator is my highest ambition," he quipped.[54] Harvard offered Henry an assistant professorship, and he finally accepted it, although he also was editor of the Boston-based *North American Review* with a small but influential circulation.

In 1871, Henry was enticed west to spend a summer with a party conducting a geological survey for the federal government. He was enthralled with the wildness of the territory. But most of all, he enjoyed meeting Clarence King, the survey's director. King was a man's man who could stare down a bear. But he also enjoyed the good things in life, wearing well-tailored clothes, bringing accomplished artists to record his geological survey of the American border with Canada and making sure the food for his exploration party was of high quality. "On meeting Clarence King, Adams felt the same instant connection he had experienced when he shook hands with John Hay. Friendship with King 'was never a matter of growth or doubt,' Adams said. It was whole from the start."[55] King had met John Hay a couple of years earlier in New York, where they also had created an instant rapport. Hay had marveled at King's humor, his grasp of art and literature

Photo of Henry Adams and his pet dog taken by Clover on the back steps of their home at 1607 H Street, across from Lafayette Park, on March 6, 1883, just as she took up photography as an art form. *Massachusetts Historical Society.*

Clover Adams.
*Massachusetts Historical
Society.*

and his "intelligent sympathy, which saw the good and the amusing in the most unpromising subjects."[56]

Back in Cambridge, Henry courted Marian Hooper, better known to friends and family as Clover. "At five-feet-two, she stood two inches shorter than Henry. With her large nose, full cheeks and prominent chin, she was not pretty, but she possessed highly developed artistic tastes and a wit so adroit that Henry Adams dove into love. 'On coming to know Clover Hooper, I found her so far away superior to any woman I had ever met, that I did not think it was worthwhile to resist.…The devil and all his imps couldn't resist the fascination of a clever woman who chooses to be loved,'" he wrote.[57] They married in June 1872.

So here we have five people bound together in friendship, and in 1880, Henry and Clover rented a house on H Street facing Lafayette Park and the White House. Hay was assistant secretary of state, with his office in the new, imposing French Empire–style building next to the White House that housed the War and Navy Departments, as well as State. (It is now known as the Eisenhower Building and contains White House staff.) King's experience leading an exploration party for six years from eastern

74

California through Wyoming and Colorado made him internationally recognized for his discoveries. In 1879, he was appointed the first director of the U.S. Geological Survey. As soon as the Adamses were settled, King and Hay dropped by almost daily for tea. Clara Hay divided her time between Cleveland and Washington, but she joined them daily when in town. They soon began calling themselves the "Five of Hearts." All of them were widely read, with an interest in history, literature and the arts. The three men earned reputations with their writing. All of them except Clara were garrulous talkers; Clara served as the audience. And all of them were short, even for the day. King was the tallest at five-foot-six, while John Hay and Clover were the shortest at five-foot-two. All of them were profoundly American, believing the country was far superior to Europe, but all had an elitist streak that feared the boundless energy of the country was producing a crass political class.[58] King, with his tales of the West, captivated the group, especially winning the admiration of John Hay and Henry Adams for acting on his ideas. And they all got a good laugh when Henry Adams anonymously published a biting satire of Washington called *Democracy*. Only they knew the identity of the author, and as sales soared, they had to bite their tongues while listening to the speculation that engulfed the city.

But by April 1881, the good times began to end. When the new president, James A. Garfield, was inaugurated in March, John Hay left the State Department and headed to New York for a short stint editing the *New York Tribune*. The job was supposed to be so laid-back that he was promised he could spend most of his time in Cleveland with Clara and their four children. But when a disappointed office-seeker by the name of Charles Guiteau shot Garfield at the train depot in Washington on July 2, Hay rushed back to New York to direct the coverage, engulfing himself in his second presidential assassination. Guiteau, a failed journalist, lawyer and public speaker, was irate when Garfield didn't even respond to his letter asking for a job as American counsel in Paris. Once again, Lafayette Park played a role in the murder and mayhem. "Brooding on a bench in Lafayette Park, Guiteau concluded that the president must be murdered and that God had chosen him for the task."[59] Guiteau's trial hinged on his sanity. Henry and Clover were eager spectators. Mental illness was something that particularly interested Clover. Once, by mistake, Clover had shaken Guiteau's hand, thinking he was someone else.

Henry immersed himself in his great opus, a multivolume history of the United States during the Jefferson and Madison administrations. King left the government and headed back west to use the knowledge he had acquired in geography and geology to get into the mining business. They held

occasional reunions, and they constantly wrote one another on letterhead Henry designed with a five-of-hearts playing card in the upper right corner. Each of them was assigned a heart. Clover lamented the breakup. "In this ever-shifting panorama of course we shall find new combinations," she wrote. "But we will hardly have the same intimate, cozy set that we did."[60] As Henry became more immersed in his work, Clover took up photography, trying to make the still-difficult photographic process into an art form.

But the Five of Hearts were still alive. Not only was John Hay looking for a summer compound for the group in New Hampshire, but the Adamses were hatching their own plans. When the property from their house on H Street all the way to Sixteenth Street came on the market, Henry proposed to the Hays that they jointly buy it to build adjoining mansions. Hay, who apparently was looking to move back to Washington, jumped at the chance. He would buy two-thirds of the property, leaving the other third to the Adamses. King was offered in on the deal but declined. His fortunes were not turning out as he had hoped. The Adamses and Hays hired one of the top architects of the day, Henry Hobson Richardson, who designed the homes to fit the late Victorian-era style, not the Federalist charm of the other Lafayette Square houses. Richardson and Adams had graduated a year apart at Harvard, and the two had become friends when Adams was in Britain and Richardson was studying architecture in Paris in the 1860s. Clover enjoyed the 365-pound Richardson for his joie de vivre. The first photo she took in 1884 was of Richardson sitting at Henry's desk.

It was a long, contentious project, but by the end of 1885, the two houses neared completion. Patricia O'Toole, in her chronicle of the Five of Hearts, describes the Hays' house this way: Frank Carpenter, a capital reporter for the *Cleveland Leader*, noted that the house cost "an eye-popping $100,000. The bricks were custom-made, wider and longer than common brick. The cavernous foyer, paneled with South American mahogany, gleamed like a new piano. Above the wainscoting walls of terra-cotta red reached to a high ceiling crisscrossed with great rafters of mahogany. The grand stairway was 'so wide that ten persons could walk abreast without jostling.' Carpenter gaped at the dining room, which was larger and more elegant than the state dining room in the White House."[61] All was set for the two happy couples to move in during early 1886. Until…

Clover had a history of suffering from depression, which ran in her family. Her greatest fear was to be put into an asylum. Over the years, Henry had tried to divert her with trips and horseback rides through beautiful countryside. She developed a fascination with mental illness, "an almost

Joint mansions built by John Hay and Henry Adams facing Lafayette Park, 1885. *Author's collection.*

gleeful interest in the illnesses and breakdowns of others."[62] During the summer of 1885, which the Adamses spent in their summer home in the Massachusetts countryside, her depression became unrelenting. And she began to fear that Henry's affections were turning toward her good friend Elizabeth Cameron, the young, beautiful and witty socialite caught in a loveless marriage with the senator from Pennsylvania. Clover terribly missed her father, one of the mainstays of her life, who had died in April. Even during the 1880s, treatments existed for depression. But many of the social elite chose not to pursue them because mental illness was a sign of weakness and scandal. In mid-October, Henry and Clover returned to Washington, but the fall weather did not invigorate her as it usually did. She seemed to revive in late November, but that may have been because she had decided to kill herself.

Natalie Dykstra, in her biography of Clover, describes Sunday, December 6, 1885, this way:

> *Henry left the house for a walk and a quick visit to the dentist about a bothersome tooth. Sunday morning was when Clover usually wrote her father from her desk next to the window overlooking Lafayette Park and the White House beyond. Without a father to write, she wrote a letter to her sister saying how patient and loving Henry had been toward her. Writing through her depression, she put the blame on herself. "If I had one single point of character or goodness, I would stand on that and grow back my*

life." If she wrote a letter to Henry, it has never been disclosed. Then she got a vial of potassium cyanide that she used in her photography and took a swallow. She was dead within minutes. When Henry returned, he found her sprawled in front of a chair near an upstairs fireplace. He carried her to a nearby sofa, but there was nothing he could do for her. He sat vigil alone with her body all day and all night.[63]

A suicide, even of someone so closely connected with a nationally prominent person as Henry Adams, probably would soon be forgotten, except for one thing: the monument Adams commissioned for her grave. In an effort to recover from his loss, Henry set out for an extended tour of Asia with his friend the artist John La Farge. Buddhism had become a topic of interest among the educated elite at the time. They sought to study the concept of nirvana, the ultimate spiritual goal to release humans from passions and pain. With its goal of inner quietude, Henry hoped he could find peace.

On their return, Henry commissioned his friend Augustus Saint-Gaudens, recognized as one of the great sculptors of the late nineteenth century, to produce a monument that encompassed these concepts, merging them with western art. The sculpture is based on Kwannon, the white-robed Buddhist deity that was neither male nor female. Saint-Gaudens used alternating male and female models to make the bronze androgynous figure shrouded in a cloak that nearly conceals the head, eyes cast down and a bare right arm raised with the hand resting on the cheek. The six-foot sculpture sits on a hunk of granite quarried in Quincy, Massachusetts, the Adamses' family home. Noted architect Stanford White designed the rosy granite bench and setting. Clover was buried in the Rock Creek Cemetery, three miles north of Lafayette Square, one of the first burial grounds for Washington, filled with the area's elite since before the Revolution. The monument is surrounded by a thick grove of high bushes that separate it from the rest of the cemetery.

John Hay, who saw the finished work after it was installed in March 1891, before the traveling Adams, wrote that it was "indescribably noble and imposing. It is full of poetry and suggestion. Infinite wisdom; a past without beginning and a future without end; a repose after limitless in this austere and beautiful face and form." Henry was pleased with the work, and he would go often to sit with it, listening to what people had to say about it as they happened by. The very ambiguity of it pleased him. No name is on the memorial. No birth and death dates. He disputed people who called it

The Adams Memorial sculpture commissioned by Henry Adams after the death of his wife, Clover, in Washington's Rock Creek Cemetery. *Wikimedia Commons.*

"Grief" and corrected them when they called it a woman. He once called it "The Peace of God." He writes of its meaning in his autobiography: "The interest of the figure is not in its meaning, but in the response of the observer....Like all great artists, Saint-Gaudens held up the mirror and no more."[64] When I visited it, someone had left a small pebble in the shape of a heart resting against the arm in the fold of the cloak.

Henry was buried next to Clover when he died in 1918.

And the other Hearts?

Clarence King suffered a number of financial setbacks since the glory days of the Hearts. But it was not until after his death that the remaining Hearts learned an astonishing secret about him. King had never married, discounting all of the eligible elite women whom the other Hearts proposed to him. He said he had no need for marriage and wanted to maintain his freedom. But unknown to his friends, he had interests that did not include the social register. When he died in 1901, Adams and the Hays learned he had led a double life. In 1888, he had married Ada Copeland, an African American nursemaid nineteen years younger than him. He had passed himself off to her as a railroad porter by the name of James Todd. Together, they had five children. The first son he named Leroy, from the French *le*

roi for the king. King would divide his time between his family and his elite friends in New York and Washington, as well as his mining ventures across North America. He even moved his growing family into an eleven-room house in Queens and hired a nurse, a cook, a laundress and a gardener to help Ada.[65] By the time King died of tuberculosis in Pasadena, California, he had moved the family to Toronto and tried to set up a substantial legacy for Ada. She was swindled out of it, but for the rest of her life, she got a modest monthly legacy from an unknown benefactor. Not until 1933 did she learn it was John Hay.

With the election of William McKinley in 1896, Hay was first appointed ambassador to Great Britain and in September 1898 came home to be secretary of state. He arrived just after the successful conclusion of the Spanish-American War, which he had dubbed the "Splendid Little War." In ten weeks, the United States Navy had defeated two Spanish fleets and American troops had driven the Spanish out of Cuba, taken over Puerto Rico and found themselves in control of the Philippines, an Asian island archipelago that many Americans had trouble finding on a map. They also had taken the Pacific island of Guam from the Spanish. Winning the war was easy. The United States had even annexed the Hawaiian Islands along the way. What to do with all of this was not so easy. The United States had suddenly become a global empire. Much of the work to make sense of this fell on John Hay. What Hay accomplished as secretary of state is worthy of its own book and not pertinent to the tales of Lafayette Park.

But on September 6, 1901, President McKinley was shot while greeting people in a reception at the Pan-American Exhibition in Buffalo, New York. His assailant, a twenty-eight-year-old mechanic named Leon Czolgosz, claimed the president should die because Czolgosz "didn't believe one man should have so much service and another man should have none." One bullet had grazed the president's ribs. The other had gone through his stomach. Doctors performed surgery and thought they had saved the president. As he rushed to Buffalo, Hay could not help but think McKinley was as doomed as Lincoln and Garfield. It had been his "strange and tragic fate to serve them all."[66]

Hay stayed on as Theodore Roosevelt's secretary of state as his health slowly deteriorated. He died in 1905. Clara left their Lafayette Square home for good in 1909. That left Henry, the last of the Five of Hearts on Lafayette Square. He finally joined Clover under the enigmatic sculpture. Two bronze casts of the monument were made with the Adams family's permission. One is in the National Museum of American Art in downtown

Washington, and the other is at the Saint-Gaudens National Historic Site in Cornish, New Hampshire.

Eleanor Roosevelt often visited the monument in 1918 while she and Franklin were having marital difficulties. She returned with a newspaper reporter in March 1933 at the time of her husband's inauguration. The reporter quoted her as saying, "In the old days…sometimes I would be very unhappy and sorry for myself. When I was feeling that way, if I could manage it, I'd come out here alone, and sit and look at that woman. And I'd always come away somehow feeling better. And stronger."[67]

As Washington society moved north in the late nineteenth and early twentieth centuries, with new mansions springing up on Dupont Circle and Massachusetts Avenue, the Hay and Adams homes became obsolete. That they would be torn down to make way for a hotel was inevitable. That a hotel of such class was named for them is only fitting. But as for stronger women, a new chapter of mayhem in the park was about to be written.

Chapter 8

WOMEN SUFFRAGISTS INVENT THE WHITE HOUSE PROTEST

For models of strong women in the second decade of the twentieth century, one need look no further than the activists in the National Woman's Party, and especially their leader, Alice Paul. The fight to gain American women the right to vote began in 1848 with the first Women's Rights Convention in Seneca Falls, New York. Elizabeth Cady Stanton issued the Declaration of Sentiments that set the agenda for women's rights and shaped the movement for decades to come. While a constitutional amendment to give women the right to vote had been defeated in Congress since it first was proposed in 1878, by 1913, nine western states, led by Wyoming in 1890, had granted women's suffrage. The National Woman's Suffrage Association, then the dominant force in the movement, believed the best way to achieve its goal was to continue to work state by state. But Alice Paul disagreed. She wanted to force Congress to pass a constitutional amendment and achieve the vote nationwide all at once. In 1913, she and Lucy Burns organized what would be known as the National Woman's Party, and Paul became the driving force in organizing it.

The National Woman's Party now is located in the historic Belmont-Sewell House right across Constitution Avenue from the Capitol. Jennifer Krafchik is the deputy director and director of strategic initiatives. Sitting in the party's archives, she described Paul this way:

> *She was a small woman, about five-foot-two or three. She had dark brown hair and very strong features. But she was very quiet. People often talked*

Alice Paul. *Library of Congress.*

about how quiet she was. She wasn't someone who went out and gave tons of speeches. You're not going to see a lot of personal information about her. While she was quiet, she was very controlling. She had a strategy in mind, and she knew what her goals were and what her overall intent was. She was difficult to persuade to think beyond her own task.

Born in 1885, Paul grew up in Paulsdale, New Jersey, and her Quaker upbringing exposed her to civil rights activism at a young age. She majored in biology at Swarthmore and went to England to study social settlements. That's how she became involved in the suffrage movement in England. She studied under Emmeline Pankhurst and the Woman's Social and Political Union. Krafchik described the group as "rabble-rousers....They were quite active, violent at times, very public in their displays against the government. Alice learned at their hand about social protest. She went to prison three times while in England. She went on hunger strikes. She was force-fed. By the time she came back to the United States, she was weakened by those experiences but curious about what was happening here."

Paul joined the National Woman's Suffrage Association in 1912, and before long convinced it to let her set up a separate committee to lobby Congress for a constitutional amendment. This became the Congressional Union for Women's Suffrage, and as Paul expanded its tactics and fundraising, she came in conflict with the association's leadership.

"Alice Paul was a big believer in spectacle, in keeping suffrage in the newspaper, organizing big parades and speaking tours," Krafchik said. "Also, she wanted to keep the money she was raising to be used entirely in the effort for the federal amendment. The two organizations split in late 1914."

Supplying a lot of the money for Alice Paul's organization was an unusual woman, Alva Belmont, who transformed herself from society maven to women's suffrage activist. She is the Belmont of the Belmont-Sewell House where the National Woman's Party now resides.

Born Alva Erskine Smith into a prominent Mobile, Alabama family in 1853, Alva summered with her parents in Newport, Rhode Island, and the family moved to New York, England and Paris, where Alva was educated. In 1875, she married William Kissam Vanderbilt, a grandson of the fabulously wealthy steamship and railroad tycoon Cornelius Vanderbilt. She pushed her way into the highest society of New York and built many mansions, including Marble House, one of the biggest "summer cottages" among the fashionable set in Newport. In 2016 dollars, that one mansion would have cost $293 million. She forced her daughter Consuelo into an unhappy

marriage with Charles Spencer Churchill, the ninth duke of Marlborough, so she could be part of British nobility.

In 1895, she divorced her husband for unfaithfulness, boasting that she was the first woman to dare divorce a Vanderbilt. With a $10 million settlement and deeds to several estates, including Marble House, the next year she married Oliver Hazard Perry Belmont, a friend of her former husband, from a prominent New York investment banking family, who had his own Newport estate. When he died suddenly in 1908, Alva inherited it all, moved back into Marble House and threw herself into the woman's suffrage movement.

"Alva Belmont worked closely with Alice Paul," Krafchik said. "She got all of that Belmont money and used it to finance women's equality. She was, if anything, more radical than Alice Paul."

The first thing Paul did after establishing the National Woman's Party was organize a suffrage parade down Pennsylvania Avenue on the day before President Woodrow Wilson was inaugurated, March 4, 1915. All the women wore white dresses with sashes promoting suffrage. Images of that parade are often used in history books to define the suffrage movement. Wilson was neither for or against suffrage. The women's vote did not play well in the Democratic Party's southern base. This is no minor thing. In the 1912 election, Wilson took every southern state by huge margins. In South Carolina, he won 96.7 percent of the vote. Republican President William Howard Taft and Progressive Bull Moose Party candidate Theodore Roosevelt didn't even appear on the ballot.

That meant Wilson had no incentive to take an active role. While he often is viewed as the Princeton University president, governor of New Jersey and ardent Progressive, he identified himself as a son of the South. Though Woodrow was born in Staunton, Virginia, in 1856, his father, a Presbyterian minister, soon moved the family to Augusta, Georgia, where he for a while was a chaplain in the Confederate army. Wilson's first wife, Ellen Axson, was born in 1860 in Savannah, where they were married. When she died in 1915, Wilson married Edith Bolling Galt, who was born in 1872 in Wytheville, Virginia. Her father had lost his plantation because he couldn't pay taxes on it after the Civil War and raised his large family in cramped quarters above a store while he served as a circuit court judge. She traced her lineage to Thomas Jefferson, Martha Washington and Robert E. Lee, as well as Pocahontas.

"Like most southern women of her time, Edith was not a big proponent of the suffrage movement," said Farron Smith, founder of the Edith Bolling Wilson Birthplace Foundation and Museum in Wytheville. "Not that she

didn't believe what they were fighting for, but she thought their behavior was very unladylike. When the president invited some of the suffragists into the White House for tea, they had refused. She didn't think that was very polite."

As a side note, Edith Bolling Wilson attained power that no woman had touched: after President Wilson suffered a stroke in 1919, some referred to her as the "acting president" while she controlled who could see Wilson and relayed to official Washington what she said were his directives. One Republican senator once labeled Mrs. Wilson "the Presidentress who had fulfilled the dream of the suffragettes by changing her title from 'First Lady' to 'Acting First Man.'"

Woodrow Wilson and his second wife, Edith, on their way to Wilson's second inaugural ceremony, March 4, 1917. *Library of Congress.*

But all of that was in the future.

How did many in the South view women's suffrage? A piece of blatant racist propaganda displayed in the museum at the Woodrow Wilson library in Staunton indicates the type of rhetoric against women's suffrage circulating in the South at the time:

Beware!

Men of the South: Heed not the song of the suffrage siren! Seal your ears against vocal wiles! For no matter how sweetly she may proclaim the advantages of female franchise—

Remember that Woman Suffrage means re-opening the entire Negro Suffrage question; loss of state rights; and another period of reconstruction horrors, which will introduce a set of female carpetbaggers as bad as their male prototypes of the sixties.

Do not jeopardize the present prosperity of your sovereign states, which was so dearly bought by the blood of your fathers and the tears of your mothers, by again raising an issue which has already been adjusted at so great a cost.

Nothing can be gained by woman suffrage and everything can be lost.

Paul believed that persuading Wilson to endorse the cause was essential to its passage. That is why she decided that if the National Woman's Party was going to be highly visible in this fight, its headquarters had to be at the president's front door—Lafayette Square. In 1915, she moved the offices to what was then known as the Cameron House on Madison Place. It had been owned by Senator Don Cameron of Pennsylvania, whose wife, Elizabeth, played a role in the previous chapter with Henry and Clover Adams. In 1915, its neighbors were the elite, men-only Cosmos Club to the north and the Belasco Theater, which had replaced Seward's home, to the south. And just outside the front door, across Madison Place, was where Representative Dan Sickles shot Francis Scott Key. By late 1916, Paul decided it was time to use their Lafayette Square headquarters as a base to begin picketing the White House to draw attention to President Wilson's inconsistent position on the issue.

Beginning in January 1917, the pickets took places outside the White House with the goal of making sure President Wilson could not leave or enter the White House without seeing their protest. Everything was fine for the first couple of months. But then the United States declared war on Germany, making Wilson the commander in chief in time of a national emergency. Paul decided this was not the time to rally around the flag. Instead, the picketers emphasized the hypocrisy of Wilson declaring that the United States was fighting to make the world safe for democracy when half of all American citizens were not allowed to participate in democracy at home.

Mary Walton describes the unfolding drama in her history, *A Woman's Crusade: Alice Paul and the Battle for the Ballot*. For a short time after the Russian tsar was overthrown, a provisional government in the Russian capital of Petrograd tried to develop a democratic government. When Secretary of State Elihu Root visited Petrograd, he said the United States valued "freedom more than our wealth" and said leaders in the United States were elected by "universal, equal, direct and secret suffrage." That infuriated Paul and the Woman's Party. What universal suffrage? When Russian officials visited the White House on June 20, members of the Woman's Party walked across Lafayette Park to unfurl a banner at the White House gate just as the car full of Russians entered:

> *To the Russian Mission: President Wilson and Envoy Root are deceiving Russia. They say "We are a democracy. Help us win a world war so that democracies can survive."*

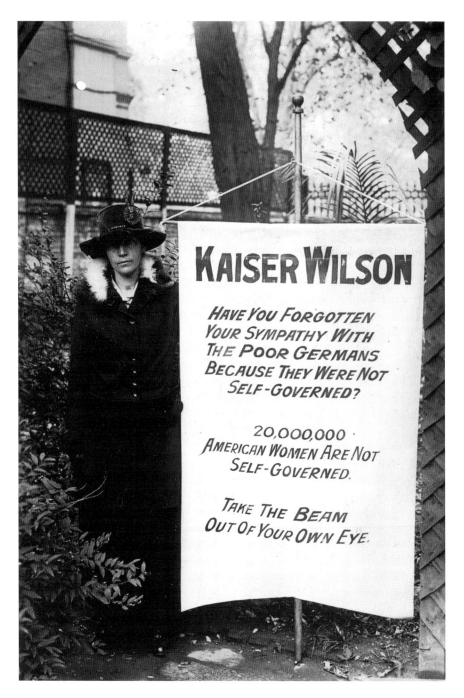

Suffragist Virginia Arnold holding a banner calling the president "Kaiser Wilson." *Library of Congress.*

We the women of America tell you that America is not a democracy. Twenty million American women are denied the right to vote. President Wilson is the chief opponent of their national enfranchisement.

Help us to make the nation really free. Tell our government that it must liberate the people before it can claim free Russia as an ally.[68]

The Russian officials would not have had time to read the banner, but it sure caught the attention of the hundreds of government workers who passed by during their lunch hour. They called the banner "treason." One fumed, "Why don't you take that banner to Berlin?" A woman shouted, "You are helping Germany." Several asked a policeman to destroy the banner. He replied, "Can't you wait until I finish copying this?" A man in a large checked cap yelled, "Come on, boys, let's tear that thing down," as he pushed forward, pulling out a penknife. He slashed the offending banner, and he and another man ripped it from the poles. The women retreated to their headquarters. That was just the beginning.

Unlike what she had witnessed with the suffrage movement in England, where protests sometimes turned violent as women broke windows, Paul advocated a more peaceful strategy. Women would unfurl their banners and make their protest, but if the banners were destroyed, they would just come back to the headquarters for more. The ensuing publicity would keep the issue in front of the nation. The next morning after the Russian banner confrontation, pickets returned to the White House with a duplicate banner. Some boys quickly tore it down. At lunchtime, four pickets emerged from the headquarters, with two taking position at both entrances to the White House on Pennsylvania Avenue. At the East Gate, the women unfurled a banner that read, "We demand democracy and self government in our own land."

According to Walton's account, a redheaded woman in a white dress darted out of the crowd and turned to the men behind her. "I'll spit on those banners if you men will follow me," she cried. After an angry exchange with Catherine Heacox, the redheaded stranger snatched the suffragists' tri-color, threw it to the ground and trampled it. Shrieking, according to some accounts, "you're a dirty, yellow traitor," she spun on Hazel, who climbed a pedestal and tried to throw her banner over the gate into the White House lawn. The woman caught Hazel around the waist, grabbed the banner and wrestled her to the sidewalk.

Through the summer, practically daily, the women activists appeared in front of the White House with banners, taunting police and getting arrested. But they all were quickly released and returned the next day for more protests. On August 10, the suffrage protests became even more provocative. This time, the banner read: "KAISER WILSON: HAVE YOU FORGOTTEN HOW YOU SYMPATHIZED WITH THE POOR GERMANS BECAUSE THEY WERE NOT SELF-GOVERNED? TWENTY MILLION AMERICAN WOMEN ARE NOT SELF-GOVERNED—TAKE THE BEAM OUT OF YOUR OWN EYE." Calling the president "Kaiser Wilson" in the middle of a war against the kaiser was too much for many people. A mob of several thousand people, including many servicemen, converged on the Lafayette Square headquarters on August 14. When a suffragist walked out with a Kaiser banner, a sailor grabbed it. She went back for another and got no farther than the corner before she was attacked. Three sailors attacked the suffragist and dragged her to the curb. When she freed herself, she ran back to the headquarters and up to the second-floor balcony, where she draped more banners over the rail. Three sailors got a ladder from the theater next door, climbed up on the balcony and tore down the banners. A bullet broke a second-floor window and lodged in the ceiling. Suffragists hung more banners from the balcony as protestors threw eggs and tomatoes. Police finally dispersed the mob, but the suffragists streamed out of the headquarters with more banners that were destroyed by members of the mob who had not left.

So far, Alice Paul had not taken part in the protests because of her fragile physical condition and because she knew she would be a special target for both the protestors and police. But the next day, she joined the pickets as they marched across Lafayette Square to the White House. A mob waiting there quickly attacked them, seizing fifty banners and flinging the women to the ground. Paul was knocked down three times, and a sailor dragged her across the sidewalk as he tried to rip off her suffrage sash. One woman had most of her clothes ripped off and wrapped herself in a banner. Police, who had threatened for a long time to arrest the protestors, moved in and seized six picketers. Instead of the usual arrest and nominal three-day jail time that had characterized past protests, these women were sentenced to thirty days in the Occoquan Workhouse and the city jail. But the jail sentences were becoming counterproductive to President Wilson. With so much publicity, people across the nation began to question why respectable women were being subjected to squalid jail conditions for peacefully demanding their right to vote.

To bring more attention, Paul purposefully worked to get a seven-month jail sentence that began on October 20, 1917. To protest the harsh conditions in the jail, she went on a hunger strike and was force-fed raw eggs through a feeding tube. Conditions were even worse for the suffragists imprisoned in Occoquan. Continuing protests and press coverage of the squalid conditions led to the prisoners' release on November 27. Knowing how to take political advantage of an event, Paul arranged for a pageant at the Belasco Theater, next door to the headquarters, to honor the eighty-nine picketers who had been imprisoned. The theater was crammed full of supporters, and thousands had to be turned away. Seeing the political damage it was doing him with the 1918 elections on the horizon, Wilson finally issued a statement in support of women's suffrage. When the House passed the amendment in January, the picketing stopped—for the moment.

In December, the all-male Cosmos Club purchased the Woman's Party headquarters on Madison Place. Not wanting to leave Lafayette Square, Alice Paul found a sizable building across the park. The Woman's Party was moving from the site of Francis Scott Key's shooting to the former home of Dan and Teresa Sickles. As a headquarters, it was ideal. The ballroom was large enough for up to three hundred people to gather, and it provided enough room for the party to open a tearoom. In those days, most women would not congregate in saloons, but tearooms gave them the opportunity to relax and converse.

With the Senate debating the amendment during the summer, Alice Paul went back into action. She believed Wilson was not doing all he could to push the amendment in the Senate. In August, she planned a new protest to rivet the nation's attention to the conflict. It would focus on the statue of Lafayette in the southwest corner of the park directly across from the White House, linking the suffrage cause to the U.S. alliance with France to fight the Germans. Lafayette, like the suffragists, fought for freedom. She recruited Red Cross volunteers, counting on them to stave off jingoists and rowdies. But she defied city authorities by refusing to get a permit for the demonstration, knowing that they probably would turn her down. On a stifling hot August 6, nearly one hundred women gathered in the mansion's ballroom and marched out of the headquarters and across the park with an American flag leading the way and banners reading "HOW LONG MUST WOMEN WAIT FOR LIBERTY?" and "WE PROTEST AGAINST THE CONTINUED DISENFRANCHISEMENT OF AMERICAN WOMEN FOR WHICH THE PRESIDENT OF THE UNITED STATES IS RESPONSIBLE." They surrounded the statue, and with a backdrop of a bronze bare-chested maiden passing a

sword up to Lafayette, one after another, they got up to speak. And one after another, they were arrested by police officers and herded into paddy wagons. In all, forty-eight women, including Alice Paul, were arrested. A total of twenty-six of them were convicted of "holding a meeting on public grounds" or "climbing a statue" and sentenced to five to fifteen days. They were housed in an abandoned workhouse on the grounds of the city jail, where conditions were worse than they had suffered before. Immediately, most of the women began a hunger strike. With the uproar from the press, all of the women were released within five days.[69]

Within days, the protesters were back again, marching across Lafayette Park, this time led by a woman holding a torch as they made their way to the Lafayette statue. "The torch which I hold symbolizes the burning indignation of women who for a hundred years have been given words without action," suffragist leader Lucy Branham said. She also held aloft a paper with the president's statement, "I will do what I can." Then, calling them "empty words," she burned the paper. No one was arrested this time, and the amendment was put back on the Senate calendar for a vote September 26.

Seeing that his lack of support could hurt his chances of holding congressional majorities, Wilson decided he must forcefully support the

A suffrage demonstration at Lafayette's statue in 1919. Lucy Branham (*center*) is burning Woodrow Wilson's words. *Library of Congress.*

amendment. On short notice, he, his wife and all but one of his Cabinet members appeared in the Senate chamber. Wilson declared woman suffrage "virtually essential" to winning the war. His own conversion came through "many, many channels," but he refused to say the protests in Lafayette Park were one of them. "The voices of foolish and intemperate agitators do not reach me," he said.[70]

The amendment still lost by two votes in the Senate. The Republican Party won majorities in both the House and the Senate in the November elections, setting up Wilson for agonizing defeat for his League of Nations. Believing Wilson had not done enough to promote the amendment, Paul launched a new series of protests on January 1, 1919, even as the president sailed for Europe to negotiate the peace treaty and urge his Fourteen Points.

In their book *Alice Paul: Claiming Power*, authors J.D. Zahniser and Amelia R. Fry describe what happened. Calling it a perpetual "watchfire of freedom," drawing on the ancient principles of an enduring flame, the idea was to maintain a fire near the White House "to consume every outburst of the President on freedom until his advocacy of freedom has been translated into support of political freedom for American women." Suffragists emerged from the headquarters to surround the urn near the Lafayette statue to start the fire, and protesters took up positions at the east and west entrances to the White House with smaller urns for their own fires. They unveiled a banner that accused the president of "deceiving the world when he appears to be a prophet of democracy." An enormous bell was set up on the balcony of the headquarters to announce a changing of the guard at the urns and the arrival of fresh words to burn. Once again, an irate mob gathered, kicking over one urn and stamping out the fire. Police arrested Paul and two other women but had to release them when prosecutors could not find anything to charge them with. The suffragists relit the fires, and they were kept burning twenty-four hours a day as police reluctantly issued a permit for the protest. Angry bystanders tried to kick over the urns and douse the flames, but the suffragists were always ready to light a new fire. Police soon lost patience and began arresting the suffragists on a charge of starting a fire after sundown in the park. They were sentenced to five to fifteen days in the city jail.

Democratic leaders in the House scheduled a new vote on the amendment for February 10, just days before the Congress adjourned and their control ended. Paul planned one last protest for February 9. As the bell on the headquarters tolled, sixty suffragists marched out of the headquarters and across the street to the White House with banners flying. Masses of people and lines of police were waiting as the suffragists quickly built a fire and

As each state ratified the amendment, Alice Paul sewed a star onto a banner. On August 24, 1920, the Tennessee legislature secured passage of the Nineteenth Amendment when it was approved by one vote. On that day, Paul draped her star-spangled banner over the second-floor balcony of the National Woman's Party Lafayette Square headquarters. *Library of Congress.*

threw in an effigy of President Wilson. The crowd was silent as police quickly arrested thirty-eight of the suffragists while the others marched back to the headquarters. Finding no compromise that would lead to passage in the Senate, Congress adjourned without another vote. Democrats knew that the new Republican majority would pass the amendment in the new Congress and take credit for its passage. And that's what happened. When the suffrage amendment came back for a vote in Congress, it sailed through the House and passed in the Senate this time.

As each state ratified the amendment, Alice Paul sewed a star onto a banner. On August 24, 1920, the Tennessee legislature secured passage of the Nineteenth Amendment when it was approved by one vote: a legislator who seemed to be firmly in the opposition camp until he got a letter from his mother asking him to vote for it. On that day, Paul draped her star-spangled banner over the second-floor balcony of the National Woman's Party Lafayette Square headquarters.

So how effective was Alice Paul's strategy? Her theory that President Wilson's active support for the amendment would ensure its passage proved to be wrong. Would the state-by-state strategy advocated by the rival National Woman's Suffrage Association have been sufficient to achieve the same end without all of the protests, arrests and recriminations?

"By 1917, New York had given women the right to vote," said Jennifer Krafchik at the National Woman's Party headquarters. "That was the tipping point. For the first time, an Eastern Seaboard state had approved it. But you also had the National Woman's Party keeping this in the newspapers and garnering public sympathy on a regular basis. I don't think you could have had one without the other."

One thing is for certain: the suffrage protests forever changed the tactics for civil rights and the history of Lafayette Park.

"These women had a large impact on the civil rights movement of the twentieth century," Krafchik said. "They were the first group to picket the White House. They set the stage for twentieth-century civil disobedience. There were a lot of groups inspired by them and continue to be inspired by them today. What happens in Lafayette Square from day to day now really owes the legacy to these women and what they set up."

We will be looking at that legacy in a future chapter. But first, we will examine how two entirely separate actions that occurred while John Hay was secretary of state came together in 1950 to inspire Puerto Rican nationalists to try to assassinate President Harry Truman within just a few steps of what had been the National Woman's Party headquarters.

SHOOTOUT AT
THE BLAIR HOUSE

T wo unrelated events that happened during the late nineteenth and early twentieth centuries—the years that John Hay was secretary of state—converged a half century later for the bloodiest encounter on Lafayette Square: an attempted assassination of President Harry Truman.

The first event was the Spanish-American War. It was fought in response to the outrage of the American people about conditions the Spanish were imposing on the Cuban people to put down a rebellion and force the island to remain a Spanish possession. The United States had coveted Cuba for decades, but the declaration of war on April 20, 1898, included the Teller Amendment that stipulated that the United States would not annex Cuba. The Cuban people would be able to create an independent country. However, there was no such stipulation for Puerto Rico, the other Caribbean island controlled by Spain. American troops had no trouble driving out the Spanish authorities in Puerto Rico, and Washington quickly set up a territorial government. But what was it to be? Was it on course like older territories in the United States to become a state? Or was it on course to eventually become an independent country like the Philippines, which also had been seized from Spain? For decades, the island was run by a civil governor appointed by the U.S. president. The president also appointed an executive council made up of six Americans and five Puerto Ricans. An assembly of thirty-five representatives was elected by the Puerto Rican people. Puerto Ricans

were granted U.S. citizenship in 1917, allowing them to move freely anywhere in the United States, but the U.S. government still held final say on any governmental action. After World War II, Congress passed a law allowing the Puerto Ricans to elect their own government. On July 4, 1950, President Truman signed an act that created Puerto Rico as a commonwealth, granting Puerto Ricans the right to draft their own constitution and establish their internal governing structures. Still, an independence movement bubbled under the surface. And that's where the situation stood in the fall of 1950.

The other event was much less noticeable. Every president likes to make changes to the White House to suit his tastes. Theodore Roosevelt was no exception. In 1902, a load-bearing wall was removed to enlarge the state dining room. While a steel beam was installed to bear the weight, it became overwhelmed with stress after President Coolidge added a third floor with bedrooms. By 1948, the White House was in real trouble, structurally. William Seale, in his two-volume history of the White House, explains the problem:

> *A remarkable transferal of stresses took place as the third floor bore down on the house underneath it. Old mortise-and-tenon timbers made for lesser purposes assumed new structural roles for which they were inadequate. One result of this process by 1948 was the weakness of the floor in Margaret Truman's bedroom. A leg of her grand piano sank into the floor, causing the plaster ceiling in the private dining room below it to fall. Likewise, in the Blue Room and the East Room, the chandeliers swayed slightly from time to time, moved by tremors from some unknown source, perhaps halfway across the house. To the fear of fire in the White House was the fear that it might collapse.*

An engineering check of the White House found the worst conditions were on the west side of the house, where the load-bearing wall had been removed. The engineers "wondered how the interior remained intact."[71] The president and his family moved across the street to the Blair House in time for Thanksgiving 1948, and the White House's interior was gutted right down to the exterior walls and rebuilt. That's why, on the unusually warm afternoon of November 1, 1950, President Truman was taking a nap on the second floor of the Blair House in a bedroom with a window overlooking Pennsylvania Avenue as two White House police officers stood guard outside the front door.

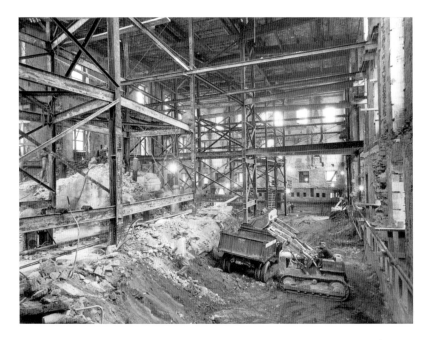

During Truman's administration, the aging White House was reconstructed. Only the walls remained standing. *White House Historical Association.*

The original Blair House, directly across Pennsylvania Avenue from what is now called the Eisenhower Executive Office Building, was constructed in 1824 as a private home for Dr. Joseph Lovell, a U.S. Army surgeon general. It is called the Blair House after Francis Preston Blair, who was the editor of the *Globe*, a newspaper that supported President Andrew Jackson. He was a member of Jackson's "Kitchen Cabinet," an informal group of advisors. He bought the house in 1836, and his family owned it for the next century. Francis Blair's son Montgomery served as postmaster general in the Lincoln administration. During World War II, the Blair family leased the house to the federal government to serve as a guest house for the many foreign dignitaries descending on Washington. During the early 1950s, the Blair House was purchased by the federal government and joined to the Lee House next door and eventually to two houses on Lafayette Square's Jackson Place to become a 119-room guest house for the president. It is now so large that it exceeds the size of the White House in floor space. But at the time that Truman occupied it in 1950, the residence encompassed the original Blair House, just about a hundred steps down Pennsylvania Avenue from the southwest edge of Lafayette Square.

Our story takes us to Puerto Rico, where revolutionary Pedro Albizu Campos was trying to jump-start his independence movement that had been dormant since he had been arrested and imprisoned in 1936. Pedro was born in Ponce, Puerto Rico's southern city, most likely in 1893. His father was Basque, a breed of tough, anti-authoritarian people from the northwestern part of Spain. His mother had been a slave with strong ties to the land. Ponce had a long history of revolutionary activities against Spain.[72]

Campos stood out from an early age. His school's leaders helped him gain a scholarship to the University of Vermont, where he worked so hard and stood out so prominently that he caught the eye of a Harvard professor, who arranged for him to transfer there. In 1916, he entered Harvard's law school and enlisted in the ROTC. Two years later, he left Harvard and returned to Ponce to organize a Home Guard Force. He became a first lieutenant. "But sometime in there, something happened: the sensitive young intellectual was confronted by the harsh realities of the racist institution that was the army. One could then track the consequences of racism as they rippled outward through society, through the long war between Albizu Campos and his oppressors, the bombs, the murders, the shootings, the whole sense of anguished anarchy that stalked both Puerto Rico and the United States as this issue was played out over the years."[73] After graduating from Harvard Law, he turned down many lucrative job offers. Instead, he became a lawyer in La Cantera, a poor section of Ponce, to support the impoverished, taking advantage of his charismatic personality. He became a leader in the Nationalist Party of Puerto Rico and sought change through the democratic system. But when he stood for election in 1932 to be a senator, he was defeated overwhelmingly. With that, he apparently decided that Puerto Rico could not gain independence through democracy. It had to come through revolution.

Much of the information in this chapter comes from *American Gunfight: The Plot to Kill Harry Truman—And the Shoot-Out that Stopped It*, written by Stephen Hunter and John Bainbridge. Calling Campos a "messianic figure," they note "he had piercing eyes that seemed to see into people and disarm them immediately....He was a fiery, spell-binding orator who knew how to draw a crowd to him and then bring them along, either to lay siege or to share a romantic and imaginary journey to an independent Puerto Rico where the modernity of the Anglo world would be irrelevant to the ideal life of the worker on the land."[74]

Declaring himself the president of the Free Republic of Puerto Rico, Campos launched a series of attacks and bombings that ended with his conviction in 1936 for inciting rebellion and for conspiracy to overthrow the government of the United States. Released in 1943, he spent four years in New York, living in the same apartment building as Oscar Collazo, who would become one of Truman's would-be assassins. When his parole was up, Campos was allowed to return to Puerto Rico, which had been peaceful since his arrest.

Campos was immediately hailed by his followers as a returning hero. Nearly four thousand people gathered at the pier to greet him when his ship arrived on December 15, 1947. An honor guard of the Cadet Corps of the Nationalist Party of Puerto Rico led a parade as an enthusiastic crowd waved placards praising Don Pedro and denouncing American imperialism. Among those proudly wearing the uniform of the Cadet Corps was Griselio Torresola. Born in 1925 in the tranquil Puerto Rican village of Jayuya, he grew up under the influence of the charismatic Campos. "How could Griselio possibly grow up any other way than devoted to this man who dazzled them all with his courage, his strength, his absolutism, his wit, his powerful oratory, and his way of seeing through things to the absolute core."[75] Torresola would do anything for Don Pedro, and even though he was only in his early twenties, he became a trusted lieutenant with a charismatic style of his own. As Campos plotted the new revolution, he sent Torresola to New York to be a secret revolutionary, raising money, communicating with the party's New York junta, carrying messages and buying ammunition. He carried a letter in his pocket from Campos allowing him to assume leadership of the movement in the United States if necessary. And he was authorized to access money for revolutionary purposes.

In New York, Torresola posed as a bookstore employee. His main contact in New York was Oscar Collazo, who was eleven years older than Torresola. He lived with his family in the Bronx.

Collazo was born in 1914, the last of eleven children in a small town called Florida in central Puerto Rico. His father owned a coffee farm with fifty workers that for Oscar was a paradise. "In Oscar's mind, it was a model for what Puerto Rico could be: lush, self-sustaining, a haven of equality and labor and happiness, producing coffee for the world."[76] But after two damaging hurricanes, his father sold the farm and died not long afterward. Oscar was sent to live with his older brother in the town of Jayuya, where he grew up and worked raising coffee. It was still

an idyllic situation for him until the Great Depression dried up jobs and the international business in coffee. For a few months, he went to New York City, experiencing life at the lowest rungs of the city's economy. He returned to Puerto Rico in 1932. That's when he came under the spell of Don Pedro Campos. Campos convinced him that the Yanqui invaders had forced his father to sell the land, destroying the idyllic life. He joined a mob attacking the capitol building in San Juan, and he found his cause in life. But finding work to support himself was another thing, and it took him back and forth to New York. He finally landed both a family and a career in New York as a metal polisher, which requires a great deal of patience and skill. The family moved into a tenement in the Bronx in 1947, where one flight downstairs lived his hero, Don Pedro Albizu Campos, while he was waiting out his parole before he could return to Puerto Rico.

On the evening of October 29, 1950, Oscar Collazo and Griselio Torresola met at Collazo's apartment and went for a walk to the Willis Avenue Bridge that separates the Bronx from Harlem. There, they talked for a long time. Torresola agreed to buy Collazo a gun.

Puerto Ricans were scheduled to register to vote on November 4 and 5, 1950, on a new constitution for their island. Campos wanted to use that event to launch his revolution to overthrow the Yanqui-backed government before the new constitution would take effect. By 4:00 a.m. on the morning of October 30, fighting had broken out all over Puerto Rico. But the attacks were sporadic and uncoordinated. The main target was the governor of Puerto Rico, Luis Munoz Marin, but police already had been alerted. They surrounded the Nationalist Party headquarters in Old San Juan, taking Campos out of the action early. On October 31, his confederates stormed the governor's palace but, with little coordinated plan, were soon gunned down by waiting police. Police then opened fire on the Nationalist headquarters. Bombs thrown out of it at police failed to explode. Some of Campos's confederates were wounded, including Torresola's sister. They were evacuated during a cease-fire. Campos held out in the compound until November 1, when, late at night, he was overcome with tear gas and captured. Puerto Rican authorities wanted him alive instead of a martyr.

On the same day, the action moved to Washington. By Monday afternoon, October 30, Torresola and Collazo knew the revolution would fail. They knew Americans would pay little attention to a failed revolution on Puerto Rico. Something much more dramatic had to

happen in Washington. They met again that night on the Willis Avenue Bridge and decided to assassinate President Truman with the prospect of gloriously dying in battle. Both men bought new suits for their mission, kissed their wives and children goodbye and bought one-way tickets to take the train to Washington. Arriving at 7:30 p.m. in a city they had never visited, they checked into a cheap hotel near the Capitol, ate dinner and plotted the next day using their only source of information: a city map in the telephone directory that allowed them to find out how to get to the White House. They didn't even know Truman was not living in the White House. Collazo still had never fired a gun like the one he had brought for the attack.

Shooting Harry Truman would not have been difficult for anyone who knew his habits. At 6:40 a.m. on the morning of November 1, as on all mornings, he was up early and out for a brisk walk through Washington accompanied by two Secret Service agents. The Secret Service always feared that Truman would be an easy target for an assassination on these walks because he took them every morning at the same time and often followed the same route. On that morning after his walk, with the temperature expected to climb to eighty-five, Truman headed to the White House pool for a swim before going to the Blair House to get dressed for the day and breakfast with his wife, Bess. Then, with the 8:00 a.m. Secret Service shift coming on duty—Floyd Boring (better known as Toad), Vince Mroz and Stu Stout—he walked to the Oval Office next to the White House to begin his day's work. On his schedule were a Medal of Honor ceremony, a speech at Arlington National Cemetery and assorted deliberations on military, political and domestic issues. It was to be a full day.

And what were the assassins doing that morning? Dressed to the hilt in their new suits, they were sightseeing. They spent an hour touring the Capitol, just like any other out-of-town visitor. After all, this was their first visit to the nation's capital. Then they hailed a cab and asked to be taken to the White House, where they thought the president lived. The helpful cabdriver, taking them for typical tourists, told them the president was living across the street in the Blair House. He pointed it out to them before they got out.

Standing across Pennsylvania Avenue from the Blair House, they examined the security arrangements—two one-man guardhouses on either side of the main entrance, two Secret Service agents constantly on patrol, disappearing occasionally to their office on the first floor, which

could be accessed through a door directly behind one of the guardhouses. Leading to the main entrance was a green canopy that crossed the sidewalk. In the warm weather, the front door was open, with only a screen door blocking entry. If they had the element of surprise, they thought, getting in looked easy. They marked their targets. Of course, they didn't know where Truman would be in the house. They didn't even know if he would be there. But they believed that once they were in, they could wreak havoc until they found the president. Even if they didn't kill Truman, even if they were gunned down in the halls, they would have attained their goal: bringing the Puerto Rican revolution to the center of American power. With all that in mind, they walked back to their hotel to prepare.

Torresola, who was an expert shot, had to teach Collazo how to fire the P.38 semiautomatic pistol he had brought. It was a sophisticated weapon of superior firepower than the guns the Secret Service agents and White House police carried. But its sophistication made it difficult to learn how to use. A process that should have taken weeks on a firing range had to be done in an hour and a half in a hotel room. Still, loaded down with extra magazines for reloading, the two assassins stuck their guns in their belts and headed back to the White House. At the same time, President Truman had finished a morning of ceremonies and meetings. At 1:00 p.m., he and his Secret Service detail walked back to the Blair House for lunch with Bess and then a nap.

At 2:20 p.m., just below Truman's open window, White House police officer Leslie Coffelt was in the guardhouse on the west side of the door, baking in the unseasonable heat. Agent Vince Mroz was with Stu Stout in the small Secret Service office inside the house. They were awaiting the president to be awakened at 2:30 p.m. for his afternoon appointments. White House police officer Don Birdzell was standing guard in front of the steps leading up to the Blair House front door. Agent Toad Boring was chatting with White House police officer Joe Davidson, who was manning the eastern guardhouse.

Ambling down the sidewalk on the Lafayette Park side of Pennsylvania Avenue came Oscar Collazo. A cab had dropped Torresola and him off near the Treasury Building. The plan was for Torresola to walk down Pennsylvania Avenue on the White House side, past the Blair House, and then cross the street and come back to the house. Meanwhile, Collazo was to walk slowly past Lafayette Park so that he would arrive at the Blair House at the same time as Torresola. Hunter and Bainbridge describe

Lafayette Square that day this way: "A joyous splurge of imperial splendor in the heart of downtown Washington, a splendid, be-statued park directly across from the White House, its trees and benches and equestrian statuary giving scale and harmony to the elegant building across the way, alas marred this day by the presence of a steam shovel out front."[77]

Collazo crossed Jackson Place and walked past the eastern guardhouse and up to Birdzell. The plan was for him to shoot Birdzell, opening the way for him and Torresola to burst into the Blair House before the other guards could react. He pulled the gun, pointed it at Birdzell's back and pulled the trigger. But instead of an explosion of a shot, there was a loud click. The gun had not gone off. Why? No one is quite sure, but since Collazo had only an hour and a half to learn how to use the complicated weapon, any number of reasons could be to blame. For the seasoned agents and officers standing nearby, the click was an unmistakable sound, and they started to

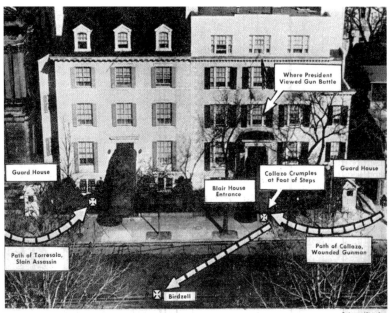

Blair House: The afternoon quiet erupted on Pennsylvania Avenue

A diagram, published just after the incident, showing the assault on the Blair House by Puerto Rican nationalists. Writers Stephen Hunter and John Bainbridge Jr. contend that Truman actually looked out the window to the left of the one marked, making him more vulnerable to Torresola. *Published by the International News Service, Wikimedia Commons.*

react. Collazo banged on the gun, and it just as unreasonably did go off, hitting Birdzell in the knee. Despite searing pain, Birdzell got past Collazo and out into Pennsylvania Avenue, drawing his pistol and firing back. Collazo, surprised that his pistol was working, took another shot at Birdzell, which missed, before he headed up the stairs to the Blair House front door. Meanwhile, in seconds, Boring and Davidson pulled their guns and took cover behind the guardhouse. As Collazo headed up the stairs, Boring took careful aim at his head and fired. But instead of bringing down the assassin, the bullet went through his hat, creasing his scalp. Collazo, his gun now working, but with no training in how to use it, fired several rounds toward Boring and Davidson, all going wild.

In the Secret Service office at the Blair House, agent Stout reacted instantly to the sound of gunshots, ran into the front hall and, looking out the screen door, saw no one there, alerting him that something was terribly wrong. He ran back into the office for a tommy gun. Knowing his job was to protect the president, he did not run out into the street. He stationed himself on the second floor outside the president's bedroom with a line of sight to the front door. If anyone rushed in, he was ready.

Meanwhile, outside, Collazo kept firing his pistol as the agents and police fired back. Despite being so close and exposed, Collazo was not hit, mostly because the officers kept hitting the wrought-iron fence that blocked him. When Collazo ran out of bullets, he simply sat down and tried to figure out how to reload the gun. By chance, he figured it out. But as he rose to fire again, he noticed something he had missed in the adrenalin rush: he had been shot squarely in the chest. He collapsed on the stairs. A total of thirty-eight seconds had elapsed since the first shot.

But what had happened to Torresola? With Collazo's first shot, the attention of the Blair House defenders focused on the eastern side of the house. Torresola strode up from the western side. Just as Collazo started firing, Torresola approached the western guardhouse, pulled out his Luger and fired four shots at Officer Leslie Coffelt, hitting him three times. Officer Joseph Downs had just talked to Coffelt, as he delivered food for dinner to Blair House through a basement door. When he heard gunfire, he turned to pull his pistol. Torresola shot him three times. Severely wounded, Downs made it through the basement door and managed to shut and lock it behind him. Attracted by the other gunfire, Torresola saw Birdzell in the street firing at Collazo. Torresola shot at Birdzell, hitting him twice before he was out of ammunition. As he reloaded, he still had not been seen by the defenders. The nearest agent rushing in that direction was still ten seconds away.

At that moment, Harry Truman, awakened by the gunfire, came to the second-floor window and even opened it to see what was happening. He saw Birdzell collapsed on the street. And he may even have seen Torresola with his now reloaded gun just about thirty feet away from him. It is Hunter and Bainbridge's contention that Torresola came much closer than anyone knew to killing Truman.

> *What is known, indisputably, is that a trained, determined assassin with extraordinary combat shooting skills and a known predilection for the highly accurate two-handed shooting stance stood with a gun he was loading, looking in the proper direction at the proper moment and unimpeded by any law enforcement agents. He had a clear shot at the window, and the president was either there or within seconds of getting there....It would have taken but a flick of the eyes, a recognition of the possibility, a few more seconds, and the Alben Barkley administration would have begun.*[78]

Then something amazing happened. Officer Leslie Coffelt, who had been shot three times at point-blank range and mortally wounded, staggered out of the guardhouse. Seeing Torresola reloading, Coffelt managed somehow through the pain and growing weakness to cock his gun, aim it and put a bullet into Torresola's head, killing him instantly. Coffelt lasted only four hours. A plaque in his honor is bolted to the Blair House wrought-iron fence.

That was the end of the incident at Lafayette Square. But it was not the end of the Puerto Rican nationalist movement and its efforts to spread mayhem in Washington. Although Pedro Albizu Campos was arrested and sentenced to eighty years in prison for his role in the 1950 uprising, Puerto Rican governor Marin pardoned him in 1953. On March 1, 1954, four Puerto Rican nationalists opened fire from the galleries on the U.S. House of Representatives, wounding five House members. Campos's pardon was revoked, even though he was not directly connected to the attack, and he was sent back to prison. He was not released until shortly before his death in 1965.

For Truman, Puerto Rico was not on the top of his list of worries as the nation became embroiled in the savage Korean War. He supported the right of the Puerto Ricans to vote on whether to become a commonwealth of the United States, and they approved it by 82 percent.

He may have been worried more about one of his worst political enemies in Congress, Senator Joe McCarthy, who with a few of his compatriots in the Senate launched one of the great stains on American history: the Red-baiting McCarthyism that told the public communists had infiltrated the government. As we shall see next, that led to a tragic incident that started in Lafayette Park and ended with the suicide of a senator.

Chapter 10

AN INCIDENT IN LAFAYETTE
PARK LEADS TO A
SENATOR'S SUICIDE

I f you want to talk about hardball politics, little approaches the story of Lester Hunt, the Democratic senator from Wyoming, and the tactics used by Senator Joe McCarthy and a couple of his Republican Senate allies in trying to force Hunt from office. McCarthy is well known for leading the "Red Scare" in American politics, using blatantly demagogic tactics to try to convince the American people that the federal government, as well as the entertainment industry, was riddled with disloyal communists trying to help the Soviet Union undermine American democracy and capitalism. Less well known, but perhaps even more damaging, was their drive to push homosexuals out of government, calling them threats to national security because they could be blackmailed by enemy agents. "Americans were as stirred up by what David K. Johnson labeled the 'Lavender Scare' as they were by the Red Scare. Homosexuals were deemed a significant threat to national security no less than Communists. Same-sex attraction was seen as a disease, a mental illness. The American Psychiatric Association was two decades away from removing homosexuality from its long list of mental illnesses."[79] That made hiding one's homosexuality, especially for government employees, paramount to those wanting to keep their jobs. And it made ferreting out homosexuality a priority for law enforcement.

That brings us back to Lafayette Park, which, as we may recall even from Lincoln's day, was a place for trysting of all sexual preferences. For a long time, using the park as a meet-up place for gays was quite open. "In the 1890s, Lafayette Park was a destination point for the annual 'drag

race' where hundreds of gay African-American men dressed in female attire filled the park after a 'dance' through the city. For many years, and certainly during the first half of the 20th century, it was a well-established gathering place for Washington's gay community."[80] But that openness changed quickly in the early 1950s as attitudes toward gays hardened and people were encouraged to be afraid of them.

Senator Lester Hunt was a New Deal Democrat in a state that leaned Republican. A former dentist, he had risen in Wyoming politics through his affable personality and dedication to public service. Born in Illinois in 1892, he first visited Wyoming as a

Senator Lester Hunt, D-Wyo. *Wyoming State Archives.*

semiprofessional nineteen-year-old baseball player. It was on that trip in 1911 that he met sixteen-year old Nathelle Higby, who had arrived in Lander in a wagon train with her family a few years earlier. When Holt finished dental school, he set up a practice in Lander but quickly joined the U.S. Army Dental Corps when the United States entered World War I. Returning to Lander after the war, he married Nathelle and returned to his dentistry practice. A daughter, Elise, was born in 1921, and a son, Lester Jr., arrived six years later in 1927. Hunt was always attracted to politics, and in 1933, he was elected to the Wyoming House of Representatives. He served two four-year terms as Wyoming secretary of state from 1935 to 1943. He was elected governor in 1942, and even though he faced hostile Republican legislatures throughout, he was the first Wyoming governor to serve two terms. Despite the state's conservative leanings, the affable Democrat swept into the U.S. Senate in 1948, and that's where he came to blows with Joe McCarthy and his associates.

Right from the beginning of his Senate career, Hunt was outraged by McCarthy's tactics. In the spring of 1949, he watched McCarthy make wild allegations about high-level military officers with no facts to back them up. The Constitution protects any senator or House member from prosecution for what he says, and McCarthy's abuse of that riled Hunt so much he proposed a constitutional amendment. Senators and House members should not have

Senator Joe McCarthy, R-Wis., who led the effort to try to hound Senator Hunt out of office. *Senate Historical Office.*

immunity to say anything vile, false and evil, calling people communists and traitors and ruining their reputations, he said. In return, McCarthy went to Hunt's home county in Wyoming and told a large crowd that the Democratic Party had become "the Commie-crat party" and no longer represented "loyal Americans." Hunt was one of the few senators who would take on McCarthy directly, but he was disappointed to see the warm reception McCarthy got among his neighbors.[81]

Lester Hunt Jr., known as Buddy to distinguish him from his father, had attended the University of Wyoming and then had been encouraged by his professors to transfer to Swarthmore, which, in keeping with everything being related in this book, was the alma mater of Alice Paul. He was active in politics there, including taking a lead in petition drives and marches objecting to McCarthy's tactics. And McCarthy had taken notice.

That brings us to June 9, 1953. Rodger McDaniel tells the tale in his book *Dying for Joe McCarthy's Sins: The Suicide of Wyoming Senator Lester Hunt.* By that time, Lafayette Park was no longer safe for gays looking for encounters. Undercover police patrolled it looking for signs of homosexual behavior. Gang members sometimes would attack them. "By far the greatest threat was posed to gay men. Some were beaten rather than arrested by undercover officers if not by gangsters. Simply being present in a known 'gay cruising' area or making eye contact with an undercover cop could result in an arrest."[82] But somehow, Buddy did not understand all that when he entered the park about 10:15 p.m. He made eye contact with John Costanzo, an undercover police officer with the police department's morals division. Buddy insisted that Costanzo was trying to solicit him by "swaggering" and "trying to attract my attention." Was it entrapment? Probably. But years later, Buddy admitted, "I wasn't framed. I guess technically it was entrapment, but I was ready for the trap."[83]

In the past, these cases would have brought little, if any, publicity. Charges were seldom pursued. Suspects were brought to the station house and questioned. They would forfeit their bond and never go to trial. But

as Congress became more involved in the issue, it transferred the duty to pursue these cases from the District of Columbia prosecutor to the U.S. attorney. The day after Buddy's arrest, the arresting officers presented the case to assistant U.S. attorney Kitty Blair Frank. She authorized "the issuance of an Information, charging Hunt with soliciting for a lewd and immoral purpose."[84] Roy Blick, the head of the D.C. Vice Squad, called the senator's office to tell him his son was in trouble. After meeting with one of Hunt's key staff members, Blick recommended to Frank that the Information be withdrawn. Frank concurred, and the charge was dropped without prosecution.

But by now, word of the arrest was circulating on Capitol Hill and got to Senator Styles Bridges, a Republican from New Hampshire and one of Joe McCarthy's key allies. Bridges and Senator Herman Welker of Idaho made up the triumvirate in the Senate that turned Joe McCarthy into McCarthyism. Bridges and Welker met three times with Blick to find out what had happened. They put pressure on Blick to reinstate the charges, saying they had heard that Blick had taken a $2,000 bribe to drop the case. The Information was refiled. Blick and Frank were taken off the case, and a warrant was issued for Buddy's arrest.

That's when Welker asked a mutual friend, Glenn "Red" Jacoby, the athletic director at the University of Wyoming, to convey to Senator Hunt that if "Hunt would retire from the Senate at the end of this term and did not run for re-election the next year, the charges against his son would not be prosecuted….If Hunt refused to resign, his son's name and the facts of the case would be smeared all over Wyoming."[85]

This was power politics. If Hunt resigned his Senate seat, his successor would be chosen by the Republican governor. In 1953, the Republicans controlled the Senate by just one seat. If Hunt were no longer a senator, the GOP would have more assurance it could keep control after the 1954 elections. While he knew it would be difficult to face his friends and family back in Wyoming if his son's trial became common knowledge, Hunt decided he would not give in to blackmail and resign.

A two-day trial was held in October 1953. Hunt was found guilty of charges and fined $100. The senator and his wife sat through the entire trial, and friends noted their terrible distress. "The charge here is one of the most degrading that can be made against a man," the judge said when passing sentence.[86]

That was supposed to be the end of it. But it wasn't. Hunt greatly aged in the coming months; his hair turned completely white in a few months.

He became depressed, blaming himself and politics for bringing his son to Washington and for forcing his son to endure the trial by not giving in to Bridges and Welker. Someone even broke into his home, ransacking it while the senator and his wife were in Wyoming. Hunt feared they were looking for something that could be used to further torment him. Would he still run for reelection in 1954? Many newspapers in Wyoming had refused to print the story about Buddy's trial. Polls showed that Hunt was still popular in his state; he would have no trouble winning reelection. On April 15, he announced he was running. He even turned down an offer from President Eisenhower for a federal position that would pay more than his Senate salary.

That's when Welker got word to him about a new threat. The Wyoming newspapers may not have run the story of Buddy's trial, but Welker already had twenty-five thousand flyers printed up with all the lurid details, and he was ready to have them distributed to voters all over the state. In his book, McDaniel explains how Hunt believed the walls were closing in around him. "He was publicly committed to a campaign for reelection. Friends had already contributed thousands of dollars. But he knew that continuing to campaign exposed his wife and son to an ordeal he could not willingly permit them to suffer." On June 4, Hunt sent a letter to the Wyoming Democratic Party chairman: "Regret exceedingly at this date to advise you that due to personal reasons beyond my control, namely health, I am compelled to withdraw my announcement as a candidate for reelection to the United States Senate."[87] He even feared McCarthy would try to raise the bogus allegation that a $2,000 bribe had been paid to get the charges against Buddy dropped. Indeed, McCarthy had told reporters on the day before Hunt committed suicide that he intended to investigate a fellow senator "who had fixed a case."[88]

Early Saturday morning, June 19, 1954, Hunt rose early, took a .22-caliber Winchester rifle from his closet and drove to his office on Capitol Hill. He knew he would arrive shortly before his chief aide, Mike Manatos. He wrote letters to his wife, to Buddy and to Manatos, and then he shot himself. In his statement issued that day to the press, Manatos blamed the suicide on "medical problems." McDaniel's investigation found no evidence that Hunt had sought treatment for any unusual medical problems. But after the suicide, Nathelle Hunt refused to cooperate with reporters who wanted to investigate what had led to it. She told reporters that her husband was "a very, very sick man." She did not want any more publicity about what had happened in Lafayette Park.

Even though he was a Democrat in a Republican-leaning state, Lester Hunt was a popular governor and senator. *Wyoming State Archives.*

But word of what really led to the suicide circulated around the Capitol. Many senators were appalled when Bridges and Welker spoke at Hunt's memorial service. McCarthy did not attend. Already he was under attack for his tactics at the Army-McCarthy hearings, where he alleged communist infiltration of the U.S. Army; his public standing faded quickly. Word that

McCarthy may also have had a hand in driving Hunt to suicide emboldened senators to oppose him.

As the historian of the Senate wrote: "Later in 1954, still reeling from the shock of Hunt's death and McCarthy's brutal tactics, senators voted overwhelmingly to censure the Wisconsin senator. Within three years, chronic alcoholism claimed McCarthy—closing the chapter on this anguished era."

So, the demise of McCarthyism may have begun on a late spring night in Lafayette Park. The incident, with names changed, appears in Alan Drury's best-selling novel *Advise and Consent* in 1959. And reference to Lafayette Park as a gay cruising spot popped up in the groundbreaking 1968 Off-Broadway play *The Boys in the Band* (made into a film in 1970), when one character accuses a presumably straight Washington lawyer visitor of "hanging out in Lafayette Park," precipitating a fistfight.

Many other things may happen in the park. But was it a drug market in the late 1980s when America's crack cocaine epidemic was taking off? That's what President George H.W. Bush told the nation in an address from the Oval Office. In the next chapter, we will see how true that was.

Chapter 11

A PRESIDENTIAL DRUG BUST

Crack cocaine burst onto the urban drug market in the late 1980s, ravaging poor neighborhoods, adding thousands of new addicts and sending murder rates skyrocketing as inner-city dealers fought for turf. While crack radiated to most urban areas, no city was as hard hit as Washington, D.C. As B. Drummond Ayres wrote in the *New York Times* on December 9, 1988, killings—many the result of wild shootouts between drug dealers on the streets—had more than doubled in the past two years. Incidents of drug abuse reported in hospitals had surged by more than 125 percent. Three out of four people arrested in the District tested positive for drug abuse.[89]

Cocaine was expensive at the time, but its derivative, crack cocaine, was cheap, easy to produce and even more addictive. It offered a short but intense high, and always the need for more. Sellers offered it in open-air markets. Anyone could buy it on the streets in poor neighborhoods. So much money could be made, and selling it was so easy, that kids were dropping out of school and quitting low-wage jobs to get into it. Not only was the drug destroying the lives of the abusers, but some babies born of crack addicts already showed signs of addiction. They became known as "crack babies." The city's efforts to stop the problem ended up with huge increases in arrests and convictions that overwhelmed the jails, courts and prisons. And even with all the arrests, Washington was well on its way to becoming the murder capital of the country.

With the crack epidemic spreading nationwide, one of President George H.W. Bush's top domestic priorities after taking office in January 1989 was

to do something about the nation's burgeoning drug abuse problem. He created the Office of National Drug Control Policy to coordinate the federal government's efforts and appointed William Bennett as its first director, better known as the "drug czar." By the beginning of September, Bush was ready to announce to the American people the strategy his administration had put together to combat crack cocaine. He decided to make the announcement in an address from the Oval Office.

Presidential Oval Office addresses are rare and usually reserved for momentous announcements in times of national emergency or major initiatives in foreign or domestic policy. Since President Truman's first one in 1947 to talk about food conservation, some of the most memorable Oval Office addresses included President Eisenhower's determination to enforce desegregation, President Kennedy's explanation of the Cuban Missile Crisis, President Johnson's decision not to seek reelection as he announced new initiatives in ending the Vietnam War and President Nixon's announcement of his resignation in the Watergate scandal. President Carter's administration was defined by his energy policy address that became known as his "malaise speech," as well as for announcing his failed attempt to rescue American hostages in Iraq. President Reagan gave a record sixteen Oval Office addresses, more than all the previous presidents combined, but the talks still hit on such major issues as the space shuttle *Challenger* explosion, the Soviet attack on a Korean civilian airliner, the Iran-Contra affair and the nomination of Robert Bork to the Supreme Court.[90]

All that set the bar high for Bush's first Oval Office address. He had to engage the American people with the seriousness of the drug problem and with his commitment to solve it through a well-orchestrated series of initiatives. One of the hurdles he had to overcome was that many Americans did not see the crack scourge near their neighborhoods. It was something plaguing neighborhoods in the inner cities, far from their homes. Washington may have become the murder capital of the nation, but the office workers downtown and tourists visiting the monuments, museums and Capitol were safe. Bush needed a hook to stir those people out of their complacency.

Looking into the camera on September 5, the president first told the American people that drugs were the "gravest domestic threat" facing the nation. They have "strained our faith in our system of justice. Our courts, our prisons, our legal system, are stretched to the breaking point….In short, drugs are sapping our strength as a nation." Crack cocaine was the leading culprit, he said.[91]

Then he picked up a bag and showed it to the camera.

"This is crack cocaine seized a few days ago by Drug Enforcement agents in a park just across the street from the White House. It could easily have been heroin or PCP. It's as innocent-looking as candy, but it's turning our cities into battle zones, and it's murdering our children. Let there be no mistake: this stuff is poison. Some used to call drugs harmless recreation; they're not. Drugs are a real and terribly dangerous threat to our neighborhoods, our friends and our families."

The speech went on for another twenty minutes. But wait a minute. Did the president just say that crack cocaine was purchased in Lafayette Park, across the street from the White House? Had Lafayette Park become a new open-air drug market? Should downtown office workers and tourists become fearful of the next wild shootout in a dealer turf war? Isn't Lafayette Park one of the most heavily guarded places in the city, what with the Secret Service, White House police, National Park Service police and city police keeping a good eye on it?

During his first address to the nation from the Oval Office, President George H.W. Bush displayed crack cocaine that had been purchased by DEA agents in Lafayette Park. *George Bush Library and Museum.*

Maybe all was not what it seemed. The *Washington Post* assigned Michael Isikoff, one of its top investigative reporters, to the story, which ran on September 22. Isikoff reported that the decision to use a bag of crack cocaine as a prop in the speech was made in August at Bush's summer retreat in Kennebunkport, Maine. The president quickly approved the plan. One White House aide told Isikoff, "He liked the prop. It drove the point home." The president's Cabinet affairs secretary contacted the Justice Department, asking it to find some crack that fit the description in the speech. But it was not to arrest someone just for the speech.[92]

DEA agents then lured a suspected drug dealer to Lafayette Park four days before the speech so that "they could make what appears to have been the agency's first undercover crack buy in a park better known for its location across Pennsylvania Avenue from the White House than for illegal drug activity," Isikoff wrote.

"We don't consider that a problem area," Major Robert Hines, commander of criminal investigations for the U.S. Park Police, was quoted as saying about Lafayette Park. "There's too much activity going on there for drug dealers. There's always a uniformed police presence there." About a half dozen arrests had been made there that year for marijuana possession, he said, but no arrests for crack.

Richard Weatherbee, the Justice Department official who got the call from the White House, telephoned James Millford, the executive assistant to the DEA administrator, who called William McMullan, who was in charge of the Washington field office. "Do you have anything going on around the White House?" McMullan recalled Millford saying. "I don't know about the White House," McMullan said he replied, but he did have undercover agents working on a buy "four or five blocks away." Millford asked, "Any possibility of you moving it down to the White House? Evidently, the president wants to show it could be bought anywhere."

DEA officials said the teenage suspect had been the target of a three-month undercover investigation. The agency had been holding off on arresting him in hope that they would discover his source and lure him into selling a larger amount of crack so that he could be charged with a more serious offense. But getting him to come to Lafayette Park was no easy task.

When first contacted by the undercover agent with the request to meet him in Lafayette Park across from the White House, the suspect's first response was, "Where the [expletive] is the White House?" according to the conversation that was secretly taped by the agent, Isikoff wrote. When the undercover agent said it was the president's home, the suspect replied, "Oh, you mean where Reagan lives."

The deal came off as planned at 11:30 a.m. on September 1 when the undercover agent purchased three ounces of crack for $2,400 while another agent hiding nearby took color photographs. The crack was delivered to the White House in time for the speech, although an agent had to sit in the Oval Office during the address to maintain the chain of custody of the narcotics. Since no arrest had been made with the purchase, the DEA worried about the suspect seeing the address on television and fleeing before he could be arrested. No need to worry. Apparently drug dealers don't watch presidential addresses.

After Isikoff's story came out, Bush was criticized by some Democrats for staging the arrest. According to the *Post*, Senator John Breaux of Louisiana asked, "Is this really a drug war or is this theatrics and

screenplay? We don't need the president to lure drug pushers to Lafayette Park for photo opportunities."[93]

Bush defended the action, saying the drug purchase had been legitimate, even if DEA agents had to lure the suspect to Lafayette Park. "I think it was great because it sent a message to the United States that even across from the White House they can sell drugs," the president told reporters. "Every time that some guy gets caught selling drugs, he pleads that somebody is luring him someplace. That's the argument of the criminal element. They say, 'somebody is setting me up; I shouldn't have been doing this.' That is probably what he'll argue to get off."

And that's pretty much what happened.

The suspect turned out to be Keith Timothy Jackson, an eighteen-year-old senior at a local high school. DEA agents finally arrested him, and he stood trial for the Lafayette Park deal, as well as three others. On December 22, 1989, a federal judge declared a mistrial after the jury deliberated the charges for four days and said it was deadlocked. The *Washington Post* reported that the jurors were hung eleven to one for acquittal on the Lafayette Park charge. "The majority of jurors felt it was a set-up," jury foreman Cheryl Adams-Huff said in an interview after the trial. "People felt as though, because it was the president saying, 'Get me something to show on TV,' the government was pressured to go out and say, 'Get anybody.'" The judge in the case called the drug sale in Lafayette Park a "Keystone Kops" transaction. One DEA agent's body microphone failed to work, and another agent attempting to videotape the sale missed the action because he was assaulted by a homeless woman in the park. Jackson's attorney called the DEA's decision to lure the suspect into Lafayette Park "an affront to the citizens of the District of Columbia." A DEA spokesman insisted the agency had acted appropriately in making the sale in Lafayette Park: "I don't think there was any mistake at all. You always try to pick the spot that's advantageous to the law enforcement authority." The jury also could not come up with a verdict on the other three charges, although at least one of them got nine votes for conviction.[94]

The retrial did not go as well for Jackson. While he was not convicted for the Lafayette Park sale, he was found guilty of the three others and received a 121-month sentence. He was released on August 5, 1998. His case sometimes draws attention by those examining the disparity in sentencing between those convicted of selling crack and those convicted of selling cocaine. Two years after his release, a reporter from Washington's *City Paper* tracked him down to a suburban Washington home. He appeared to be doing fine, but

he refused to talk to the reporter or to any of the other reporters who had tried to get his story.[95]

While the Lafayette Park drug sale involved a suspect who didn't even know where the park was, the heirs to the women's suffrage movement certainly do. Nearly every day, someone is in the park across the street from the White House, following the suffragists' example by protesting something. For at least a couple of them, staging an antiwar protest became a lifelong mission, day-in-and-day-out through five presidential administrations. What motivates them and all the others who think they can influence policy by bringing their cause to the park will be examined in the next chapter.

Chapter 12

THE NEVER-ENDING PROTEST

The women suffragists lit a fire both literally and figuratively that still burns today. When they took their protest for demanding the right to vote to Lafayette Park and the White House fence—including burning Wilson's words in urns—they developed a tactic for political activism that has been embraced by American civil rights and antiwar groups. Even international activists seeking to draw attention to the plight of citizens in their homelands make regular appearances with their banners, chanting their slogans for freedom.

While protests that draw hundreds of thousands of people take over the National Mall and Ellipse on the other side of the White House, Lafayette Park is considered a more "personal venue" for demonstrators, according to the White House Historical Association. "Lafayette Park, as the front yard of the White House, played an integral role in bringing the government and the people within reach of each other. The president could not ignore what the people were saying."[96]

Not to say presidents didn't want to ignore them.

As writer Roger McDaniel pointed out, "During the Gulf War, President George H.W. Bush was annoyed with an anti-war demonstration in Lafayette Park. An 'incessant' drumbeat used by protestors was so loud he ordered the drums silenced. 'Those damn drums are keeping me up all night,' Mr. Bush told a group of visiting congressmen. But a federal court held the park was a public place. The whole point of free speech was to get the attention of the President. The beat went on."[97]

Some sort of protest is happening practically daily. The National Park Service requires any group of twenty-five or more to obtain a permit before launching a rally in Lafayette Park. In 2016, that amounted to 114 permits, the same as the year before. That does not include protests on the sidewalk in front of the White House—another 26 permits in 2016. Not included is any group of fewer than twenty-five people. They can show up and exercise their First Amendment rights any time they want.

Alice Paul led her Lafayette Park protest for more than a year and a half. But that was just a blink of an eye compared to what a five-foot-tall Spanish-born woman by the name of Concepcion Picciotto endured. From 1981 until her death in January 2016, she and a small group of antiwar protestors held an around-the-clock vigil in the park across Pennsylvania Avenue from the White House. Alice Paul's protests had a finite ending. When women achieved the right to vote, it was over. But Concepcion, who went by the name "Connie," was calling for the abolition of nuclear weapons and the end to U.S. intervention in foreign wars. That's a goal that may not have a resolution anytime soon.

Picciotto wore a helmet covered by a huge wig and scarf that framed her weather-beaten face. Only two teeth were apparent when she opened her mouth. When I interviewed her in May 2001, the twentieth anniversary of her vigil, schoolchildren were studying her poster that said, "Stay the Course and This Will Happen to You" with pictures of mounds of skulls, charred bodies and suffering people. In her constant battle with National Park police, she had become a lesson in First Amendment rights. "I'm going to be here until the government comes to its senses and eliminates the weapons of mass destruction and stops provoking wars," she told the children. "There's too much greed for money and control inside there," she said, pointing at the White House. "They're stealing money from social programs." And that was before the Afghan and Iraq wars that started just months later and outlasted Concepcion's life.

William Thomas began the protest on June 3, 1981, with a sign saying "Wanted: Wisdom and Honesty." He was soon joined by Picciotto, and they created a makeshift shelter and squatted there, spelling each other around the clock, defying the Park Service that wanted them out. In the process, they became an institution of their own, a regular stop for school tour groups, whose leaders made them lessons in freedom of speech and the right to protest government policies.

As the *Washington Post*'s David Montgomery wrote in the *Post* on the twenty-fifth anniversary of the protest, "Take Lafayette out of Lafayette Square—

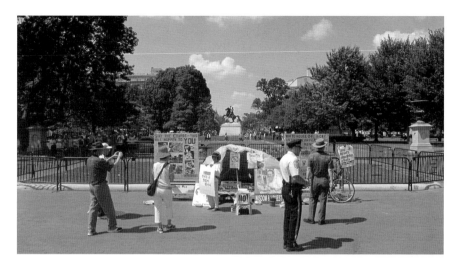

Concepcion Picciotto posing for tourists at her decades-long protest in Lafayette Park. *Wikimedia Commons*.

the monumental statuary likeness of the Frenchman, with Colonial braid, big boots and a sword—and hardly anyone would notice. But get rid of the shelter made of a tattered patio umbrella, a weathered plastic tarp and those faded anti-nuke signs erected by Thomas and Picciotto? It wouldn't be the same park."[98]

So who are these people, and how did this happen?

William Thomas was born William Thomas Hallenback Jr. in 1947 in North Tarrytown, New York. Dropping his last name, everyone knew him as Thomas. According to a column written by Colman McCarthy at the time of Thomas's death in 2009, he "once described himself as a former heroin addict with a jail record stretching from New York (for car theft) to Egypt (for a visa violation). Along the way, he owned a jewelry-making business in New Mexico."[99] After throwing his passport into the Thames River in London to renounce his U.S. citizenship, he was deported and ended up in Washington in 1980, volunteering at the Community for Creative Non-Violence (CCNV), a homeless advocacy group. Joining CCNV for a protest in front of the White House one day in 1981, he decided to make that his life's work. He made his sign, sat down and never left.

Connie Picciotto's story was more complicated and shrouded in more mystery, as it was chronicled in a *Washington Post Magazine* cover story by Caitlin Gibson in May 2013. Born in Spain, Picciotto never told anyone who interviewed her how old she was. Her obituary said she was believed

to be eighty when she died in 2016. She immigrated to the United States in 1960 and worked as a secretary for the Economic and Commercial Office of the Spanish embassy in New York City. She got her American citizenship and married "a dark haired Italian man" in 1969. When they could not have children, they went to Argentina and adopted a newborn girl. Connie insisted that then her husband wanted her to "disappear." That's when the story gets very complex with her commitment to a mental hospital, her flight back to Spain and then her return to the United States by way of Canada in her effort to get her daughter returned to her. When efforts through lawyers in New York failed, she came to Washington.[100]

"That's how my odyssey began, seeking legal help," she told Gibson. "I was trying to get custody of my baby." But after months in Washington with no luck, she became convinced that she was being persecuted by the government.

"That's why she wears the helmet; the government, she says gravely, is aiming electromagnetic waves at her head," Gibson wrote. "Why? 'That's a complicated story,' she says, then offers a simple answer: 'They want to stop me.'"

That was the situation when Connie sat down next to Thomas in June 1981. "Since I couldn't do anything to help my child, the only thing to do was to help the other children of the world. I had to keep them from being destroyed," she told Gibson.

On the first day, Connie sat at one end of the sidewalk and Thomas at the other. Camping in Lafayette Park is illegal, and within hours of their beginning their vigil, they were arrested for camping. On their release, Gibson wrote, Thomas told her, "Since we are both seeking peace and justice, we should become a team."

It took years of give and take, and Thomas was once jailed for ninety days, but the peace vigil made its own peace with the Park Police and Secret Service, Montgomery wrote. They could maintain their vigil twenty-four hours a day, as long as they don't "camp." They can nod off, but there can be no bedding. They can't stray more than three feet from their signs, and the signs can't be too large. "We make it look like a free country," Thomas told Montgomery. "We're an asset to the government. So they don't pay much attention and pretend we're not here."[101]

That kept them in close quarters around the clock. And then in 1984, a woman by the name of Ellen Benjamin showed up at the vigil and met Thomas. As she told *Washington Post* columnist John Kelly in 2011, "I actually dreamed his face, his voice, his words and his location for years and years,

many times before I met him." She quit her job at the National Wildlife Foundation, married Thomas and joined the vigil. Connie was none too pleased. "Originally, she told everybody that I worked for the government or was a cop," Ellen told Kelly, while Connie told him, "She hated me because I took care of Thomas."[102] Yet they still maintained their vigil together for twenty-five years.

And so they sat, through snow and freezing rain, heat, humidity and hurricanes. They handed out their literature to anyone who would stop. They were subject to countless photographs, infinite questions, endless indifference and lots of ridicule.

The *Washington Post*'s Kris Coronado caught one such incident in a 2011 article. A group of well-dressed tourists gazing at the White House turned around to spot Connie and her makeshift vigil. She was rearranging the signs after the U.S. Park Police had briefly relocated her to the park's northwest corner for an undisclosed reason. "It's so hard," she told them. "For two hours they made us move everything and wait." One of the tourists laughed at the notion that a vigil that had lasted decades would have to move. Connie struck back: "Well, I have this here because you do nothing. You people go around like robots with cameras. If you people were more concerned, we wouldn't have to be here." The group scoffed and mockingly made robot movements before walking away laughing.[103]

One thing the three did accomplish was helping to pass what was known as Proposition One, which grew from petitions handed out by the vigil and led to an initiative approved by District of Columbia voters in 1993 that called for nuclear disarmament. Eleanor Holmes Norton, D.C.'s non-voting delegate to the House of Representatives, crafted the language of the initiative into a nuclear disarmament and conversion act, which she repeatedly introduced in the House—to no avail.

"They want to keep the issue of nuclear proliferation and its potential terrible consequences before the public," Norton told Gibson. "And they have chosen a prime spot to do it.…We won't ever know what the success is, because it doesn't have a specific end of the kind we are used to."[104]

In 1999, Thomas inherited some money on the death of his mother and used it to buy a dilapidated home on Twelfth Street NW. The group turned it into a "Peace House," which Kelly described as a "crash pad for peace activists."

"The idea for the Peace House was mine," Ellen said on a video posted at the time of Connie's death. "When Thomas's mother died, she left him some money. He had been saying if he ever got any money, he would take

it out into the streets and burn it. I told him it was a bad idea. It would be a nice place where we could set up a computer and take showers. He agreed."

The Peace House helped provide some volunteer labor to man the vigil, especially after Thomas died in 2009 and Ellen, who inherited the house from Thomas, moved on to North Carolina. Connie found a small room in the basement to sleep when she was not at the vigil. By 2016, Ellen said she could no longer keep up with paying for the maintenance and taxes on the house and had to sell it.

Videos of Connie speaking can be found on the Internet, on YouTube and at the *Washington Post* site where her obituary was posted. "We have to protect the planet from nuclear catastrophe," she says in a high, slightly accented voice for what must be the zillionth time in the three decades she had been there. "We need a safe place for future generations." In her later years, her protest took on new controversy by supporting Palestinians against Israel. Even after she was hit by a cab in 2012 while she was riding her bicycle, Connie showed up daily at the vigil.

As Gibson wrote in Connie's obituary, to the end she insisted she must remain at her post. "I have to be here. This is my life."[105]

But that was not the end of the story—or the end of the protests. On an exceptionally hot July day in 2017, I wandered through Lafayette Park to see what was happening. Under the banner of the Hip Hop Caucus, dozens of protestors moved out of the park onto Pennsylvania Avenue. They represented

Concepcion Picciotto in place at her decades-long protest in Lafayette Park. *Wikimedia Commons.*

such groups as the National Organization for Women, the ACLU and the NAACP. They were protesting what they saw as the Trump administration's moves to suppress voter turnout that would diminish participation among minorities, the poor and the young. They waved signs that read, "End Voter Suppression" and T-shirts that read, "Election Protection." A leader juiced up the crowd's energy: "We're saying you will respect our vote!" he shouted. "Everyone do me a favor, put your right hand in the air," and the crowd responded. "Say, Power," he urged. "Power," they shouted back. "Say, Power," he urged again. "Power," they shouted back. "One last time, say it like you mean it so they can hear it in the building behind me. POWER." And the crowd responded with a rousing "POWER."

Demanding that the White House hear their rally for voter rights on the edge of Lafayette Park? Alice Paul would have been pleased.

Just a few feet away, a group of Chinese held up banners with their own messages: "Chinese Communist Party Is Harvesting Organs from Falun Gong Practitioners," read one. "Falun Dafa Is Great," said another in both English and Chinese. Said a third, "Destruction of CCP [Chinese Communist Party] Mandated by Heaven. Quitting the CCP Is Helping Oneself."

Tourists mingled among the protestors. Take a picture of Junior in front of the White House, get a shot of Sis with Lafayette's statue. Get a family group shot with some protestors. It was all part of the Washington experience.

And along the fence separating the White House from the crowd, uniformed Secret Service and White House police, seemingly more heavily armed than in years past, watched warily. In the past year, some people had leapt over the fence to gain entry to the grounds. One had made it all the way into the East Room. Another makeshift barrier had been set up to make it harder for people to reach the main fence. Skateboarders, strollers and rollerbladers had largely disappeared from the avenue. The guards seemed more willing to push people back, close the avenue entirely by extending "Do Not Cross" tape.

But what is that on the sidewalk, behind the voting rights protestors, next to the Chinese Falun Gong? It's the makeshift encampment with its signature tarps and signs warning of catastrophe unless nuclear bombs are banned. Eighteen months after Connie's death, the nation's longest protest continues. Sitting on a wheelchair in the heat is Philipos Melaku Bello, his long dreadlocks tied under a knit cap, a big smile of welcome on his face. He's glad to see you. He says his father was Thomas's good friend and his godfather. He has been involved in the protest off and on since its

After the death of Picciotto, Philipos Melaku Bello took over leadership of the thirty-four-year-old antiwar protest across the street from the White House. He says he logs about one hundred hours per week. *Photo by author.*

inception, as well as antiwar rallies in other parts of the country. When he saw Connie's health declining, he said, he started coming every day.

He insists he does not have a political agenda, just an agenda of peace. "I am not a left-winger or a right-winger," he says. "I'm here because I stand up for humanity. I love the civilians of the planet, and I don't believe any civilian should be targeted by any nation's military in an act of war." But it

is getting harder to maintain the vigil, he says. At one time, it had nineteen volunteers so that no one had to do more than three shifts a week. "One of the volunteers just quit, so now there's me and two others. One does 38 hours a week and one does 30 hours. There are 168 hours in a week, so I do 100." But he says he will keep going as long as he can. After all, he comes from a good pedigree.

"Do you remember the Drums of Thunder in 1991?" he asks of the protest that drove President George H.W. Bush to distraction. "That was us and a lot of my friends." A big smile crosses his face.

Sometimes it's hard to hear Philipos because behind him a woman with a sign that identifies her as evangelist Melodie Crombie is preaching and singing into a bullhorn. With police restricting access to the avenue, it's gotten a little tight along the sidewalk. But as I move north from the avenue away from the White House, the hubbub starts to die away. Even in the heat, people are sitting on benches in the shade, chatting and relaxing. The Bernard Baruch bench still offers a spot for inspiration.

Yes, all is peaceful in Lafayette Park—until it isn't.

Notes

Chapter 1

1. www.visitwashingtondconline.com/washington_dc_history7.htm.
2. Hutchinson, *History of Madison Place*, 12–13.
3. Ibid., 19.

Chapter 2

4. Tucker, *Stephen Decatur*, 52.
5. Ibid., 126.
6. Ibid., 132–33.
7. Ibid., 136.
8. McKee, *Gentlemanly and Honorable Profession*.
9. Tucker, *Stephen Decatur*, 137–39.
10. Allison, Stephen Decatur. All of the quotes here describing the funeral come from the Prologue, "The Navy Has Lost Its Mainmast."
11. *Chicago Tribune*, "Three Washington Houses," 13.

Chapter 3

12. Meacham, *American Lion*, 21.
13. Ibid., 4–5.

14. Widmer, *Martin Van Buren*, 7–8.
15. Meacham, *American Lion*, 67.
16. Ibid., 68.
17. Widmer, *Martin Van Buren*, 77.
18. Meacham, *American Lion*, 68.
19. Ibid., 117.
20. Ibid., 17.
21. Howe, *What Hath God Wrought*, 339.
22. Widmer, *Martin Van Buren*, 81.
23. Ibid., 79–80.
24. Text of Calhoun's speech from *Congressional Globe*, 31st Congress, 1st Session, vol. 22, part 1 (1850), 451–55.

Chapter 4

25. Bowling, *Creation of Washington D.C.*, 212.
26. www.ushistory.org/presidentshouse/slaves/index.php.
27. Jennings, *Colored Man's Reminiscences*, 7–8.
28. Ibid., 14–15.

Chapter 5

29. Keneally, *American Scoundrel*, 2–3.
30. Ibid., 75.
31. Fogle, *Proximity to Power*, 73.
32. Keneally, *American Scoundrel*, 77.
33. Ibid., 66.
34. Hutchinson, *History of Madison Place*, 82.
35. Ibid., 81.
36. Keneally, *American Scoundrel*, 83.
37. Ibid., 127–29.
38. Hutchinson, *History of Madison Place*, 84.
39. Keneally, *American Scoundrel*, 195.

Chapter 6

40. Winkler, *Stealing Secrets*, 4.
41. Ibid., 7.
42. Ibid., 11–12.
43. Ibid., 24.
44. Goodwin, *Team of Rivals*, 383.
45. Ibid., 364.
46. Ibid., 365.
47. Stahr, *Seward*, 432.
48. Goodwin, *Team of Rivals*, 724–25.
49. Brooks, *Washington D.C. in Lincoln's Time*, 223.
50. Goodwin, *Team of Rivals*, 728.
51. Stahr, *Seward*, 1–3.

Chapter 7

52. O'Toole, *Five of Hearts*, 49–50.
53. Ibid., 7.
54. Ibid., 7.
55. Ibid., 11.
56. Dykstra, *Clover Adams*, 11.
57. O'Toole, *Five of Hearts*, 13.
58. Ibid., 69–70.
59. Ibid., 88.
60. Dykstra, *Clover Adams*, 116.
61. O'Toole, *Five of Hearts*, 155.
62. Dykstra, *Clover Adams*, 200.
63. Ibid., 204.
64. Ibid., 220.
65. O'Toole, *Five of Hearts*, 279.
66. Ibid., 335.
67. Dykstra, *Clover Adams*, 221.

Chapter 8

68. Walton, *Woman's Crusade*, 171.
69. Zahniser and Fry, *Alice Paul*, 304–5.
70. Ibid., 308.

Chapter 9

71. Seale, *President's House*, 1026.
72. Hunter and Bainbridge, *American Gunfight*, 23–24.
73. Ibid., 26.
74. Ibid., 9.
75. Ibid., 13.
76. Ibid., 113.
77. Ibid., 111.
78. Ibid., 242.

Chapter 10

79. McDaniel, *Dying for Joe McCarthy's Sins*, 251.
80. Ibid., 245.
81. Ibid., 239–40.
82. Ibid., 253.
83. Ibid., 254.
84. Ibid., 280.
85. Ibid., 287–88.
86. Ibid., 289.
87. Ibid., 297.
88. Ibid., 297–98.

Chapter 11

89. Ayers, "Washington Finds Drug War."
90. Wikipedia, "Oval office address list."
91. Bush, text of address to the nation.
92. Isikoff, "Drug Buy Set Up."

93. Hoffman, "Bush Defends Luring Drug Suspect."
94. Gellman, "Mistrial Declared in Cocaine Arrest."
95. Silverman, "Presidential Unpardoned."

Chapter 12

96. White House Historical Association, www.whitehousehistory.org/anti-war-protests-of-the-1960s-70s.
97. McDaniel, *Dying for Joe McCarthy's Sins*, 245.
98. Montgomery, "Long Wait for Peace."
99. McCarthy, "From Lafayette Square Lookout."
100. Gibson, "The Protester."
101. Montgomery, "Long Wait for Peace."
102. Kelly, "For 30-Year Peace Activist, a New Battle."
103. Coronado, "Whatever happened to…?"
104. Gibson, "The Protester."
105. Gibson, "Concepcion Picciotto."

BIBLIOGRAPHY

Books

Allison, Robert J. *Stephen Decatur: American Naval Hero, 1779–1820*. Amherst: University of Massachusetts Press, 2005.

Bowling, Kenneth R. *The Creation of Washington D.C.: The Idea and Location of the American Capital*. Fairfax, VA: George Mason University Press, 1991.

Brooks, Noah. *Washington D.C. in Lincoln's Time: A Memoir of the Civil War Era by the Newspaperman Who Knew Lincoln Best*. Edited by Herbert Mitgang. Athens: University of Georgia Press, 1989.

Dykstra, Natalie. *Clover Adams: A Gilded and Heartbreaking Life*. Boston: Houghton Mifflin Harcourt, 2012.

Fogle, Jeanne. *Proximity to Power: Neighbors to the Presidents Near Lafayette Square*. Washington, D.C.: Tour de Force Publications, 1999.

Freidel, Frank. *The Splendid Little War*. New York: Bramhall House, 1958.

Goodwin, Doris Kearns. *Team of Rivals: The Political Genius of Abraham Lincoln*. New York: Simon and Schuster, 2005.

Howe, Daniel Walker. *What Hath God Wrought: The Transformation of America, 1815–1848*. New York: Oxford University Press, 2007.

Hunter, Stephen, and John Bainbridge Jr. *American Gunfight: The Plot to Kill Harry Truman—And the Shoot-out that Stopped It*. New York: Simon and Schuster, 2005.

Hutchinson, George E. *The History of Madison Place, Lafayette Square*. Washington, D.C.: Federal Circuit Historical Society, n.d.

Jennings, Paul. *A Colored Man's Reminiscences of James Madison.* N.p.: George C. Beadle, 1865.

Junior League of Washington. *The City of Washington: An Illustrated History.* Edited by James Frock. New York: Alfred A. Knopf, 1985.

Keneally, Thomas. *American Scoundrel: The Life of the Notorious Civil War General Dan Sickles.* New York: Anchor Books, 2001.

Lee, Richard M. *Mr. Lincoln's City: An Illustrated Guide to the Civil War Sites of Washington.* McLean, VA: EPM Publications Inc., 1981.

Levasseur, Auguste. *Lafayette in America in 1824 and 1825, Journal of a Voyage to the United States.* Translated by Alan R. Hoffman. Manchester, NH: Lafayette Press, Inc., 2006.

McDaniel, Rodger. *Dying for Joe McCarthy's Sins: The Suicide of Wyoming Senator Lester Hunt.* Cody, WY: WordsWorth, 2013.

McKee, Christopher. *Gentlemanly and Honorable Profession: The Creation of the U.S. Naval Officer Corps, 1794–1825.* N.p., 1991.

Meacham, John. *American Lion: Andrew Jackson in the White House.* New York: Random House, 2008.

Olszewski, George J. *Lafayette Park: Historical Research Series Number 1.* Washington, D.C.: U.S. Department of Interior, 1964.

O'Toole, Patricia. *The Five of Hearts: An Intimate Portrait of Henry Adams and His Friends, 1880 to 1918.* New York: Simon & Schuster, 1990.

Seale, William. *The President's House: A History.* Vol. 2. Washington, D.C.: White House Historical Association, 1986.

Shepherd, Jack. *The Adams Chronicles: Four Generations of Greatness.* Boston: Little Brown and Company, 1975.

Stahr, Walter. *Seward: Lincoln's Indispensable Man.* New York: Simon & Schuster, 2012.

Tucker, Spencer. *Stephen Decatur: A Life Most Bold and Daring.* Annapolis, MD: Naval Institute Press, 2005.

Walton, Mary. *A Woman's Crusade: Alice Paul and the Battle for the Ballot.* New York: St. Martin's Griffin, 2015.

Widmer, Ted. *Martin Van Buren.* New York: Henry Holt and Company, 2005.

Winkler, H. Donald. *Stealing Secrets: How a Few Daring Women Deceived Generals, Impacted Battles, and Altered the Course of the Civil War.* Naperville, IL: Cumberland House, 2010.

Zahniser, J.D., and Amelia R. Fry. *Alice Paul: Claiming Power.* New York: Oxford University Press, 2014.

Newspaper and Online Sources

Ayers, Drummond. "Washington Finds Drug War Is Hardest at Home." *New York Times*, December 9, 1988.

Bush, George. Text of Address to the Nation on the National Drug Control Strategy, September 5, 1989. www.presidency.ucsb.edu/ws/?pid=17472.

Chicago Tribune. "Three Washington Houses: The Homes of the Late Gen. Myer, Gen. Edward Beale, and of the Japanese Minister." December 23, 1883.

Coronado, Kris. "Whatever Happened to…the Protesters at Lafayette Square Park?" *Washington Post*, January 30, 2011.

D.C. Crack Epidemic. lheslop.omeka.net/essay.

Gellman, Barton. "Mistrial Declared in Cocaine Arrest Near White House." *Washington Post*, December 22, 1989.

Gibson, Caitlin. "Concepcion Picciotto, Who Held Vigil outside the White House for Decades, Dies." *Washington Post*, January 25, 2016.

———. "The Protester: 32 Years in Front of the White House: Her Cause and Its Cost." *Washington Post Magazine*, May 5, 2013.

Hoffman, David. "Bush Defends Luring Drug Suspect: Sen. Breaux Criticizes 'Theatrics' in Use of Cocaine as Prop." *Washington Post*, September 23, 1989.

Isikoff, Michael. "Drug Buy Set Up for Bush Speech: DEA Lured Seller to Lafayette Park." *Washington Post*, September 22, 1989.

Kelly, John. "For 30-Year Peace Activist, a New Battle." *Washington Post*, November 6, 2011.

McCarthy, Colman. "From Lafayette Square Lookout, He Made His War Protest Permanent." *Washington Post*, February 8, 2009.

MetaFilter. "The Kid Who Sold Crack to the President." August 20, 2010. www.metafilter.com/94969/The-Kid-Who-Sold-Crack-to-the-President.

Montgomery, David. "A Long Wait for Peace, 25 Years Ago, Two People Sat Down in Lafayette Square. They Haven't Budged Yet." *Washington Post*, June 3, 2006.

Silverman, Elissa. "Presidential Unpardoned: These Days You Just Can't Hook Up with President George Bush's Hookup." *Washington City Paper*, September 8, 2000.

Wikipedia. "List of Oval Office addresses." en.wikipedia.org/wiki/Oval_Office_address#List_of_Oval_Office_addresses.

About the Author

Gil Klein is the Washington program coordinator for the University of Oklahoma's Gaylord College of Journalism and Mass Communications. A former journalism professor at American University, he is also a freelance writer. He was a daily newspaper reporter for nearly thirty-five years, the last twenty-two in Washington as a national correspondent for the Media General News Service. He was president of the National Press Club in 1994 and wrote its centennial history: *Reliable Sources: 100 Years at the National Press Club*. He is a graduate of Rollins College and holds a master's degree in communication from American University. He lives with his wife, Gail, in Arlington and has two grown children.

Visit us at
www.historypress.com
···